THE
GOLDEN AGE
OF
YORKSHIRE
RESORTS

1800–1914

GEORGE SHEERAN

AMBERLEY

Cover illustration: Cuthbert Brodrick's rendering of the Cliff Hotel, Scarborough (1862), which was to become the Grand Hotel after some later alteration.

Acknowledgements

I wish to thank the following people and organisations for their assistance: Dr Paul Jennings, Dr David Pendleton and Yanina Sheeran for commenting on earlier sections and drafts; also Dr David Neave for further comment. The staff of East Riding Archives and North Yorkshire County Record Office for their unstinting help. For permission to reproduce images in their collections: Brierley Groom, Architects, York; Crimlisk Fisher Archive, Filey Town Council; East Riding of Yorkshire Council; Royal Institute of British Architects; and Scarborough Borough Council.

First published 2023

Amberley Publishing, The Hill, Stroud
Gloucestershire GL5 4EP

www.amberley-books.com

British Library Cataloguing in Publication Data.
A catalogue record for this book is available from the British Library.

ISBN 978 1 3981 1345 9 (print)
ISBN 978 1 3981 1346 6 (ebook)

Typesetting by SJmagic DESIGN SERVICES, India.
Printed in Great Britain.

Contents

I

Yorkshire's Coastal Resorts

On 19 July 1824, the *Morning Post* could report from Scarborough that 'the weather has been uninterruptedly fine and warm, and the influx of visitors very great'. Visitors included the Duke of Devonshire, who had been residing in Bridlington; the Earl of Seaford and his family; Sir George and Lady Sitwell; and Sir Robert Peel accompanied by the Dean of York. On 18 August 1827 the same paper reported that the Duke of Wellington was to visit Scarborough, and 'not a lodging room in the fashionable part of the town is to be had, and beds are engaged in the New Borough at extravagant prices'. Newspapers of the early nineteenth century carry similar reports of other places along the Yorkshire coast, indicating that a number of resorts were already established and, it would appear, were flourishing. Bridlington Quay, Coatham, Scarborough and Whitby were all considered to be 'fashionable watering places', to use the language of the day.

Scarborough's importance as Yorkshire's earliest resort rested not only on its possession of a mineral spring, or spa, but also on its location by the sea. It was probably the first resort in England to promote itself in this respect, and until the mid-eighteenth century possibly the only one on Yorkshire's coast. Yet there was one competitor, for by perhaps 1700 a spring had also been discovered at Whitby and seems to have been attracting visitors. It rose at the foot of the cliffs on the beach, and by 1734 it was described by Thomas Short in his *The Natural ... History of the Mineral Waters of ... Yorkshire, Particularly those of Scarborough*, as walled and having 'a house and several conveniences for drinkers'. However, by that date the sea had 'wash'd down all, and fill'd the place with stones'. That sea bathing was also taking place is attested to by a poem of 1718 in praise of Whitby, containing the lines:

> And what the Drinking cannot purge away,
> Is Cur'd with ease by Dipping in the Sea.
>
> (Samuel Jones, 'Whitby, A Poem...')

Perhaps the destruction of Whitby's spa and its difficulty of access compared with Scarborough led to its demise as an early seaside resort. Scarborough, on the other hand, seems to have made steady progress. Nevertheless, it is clear

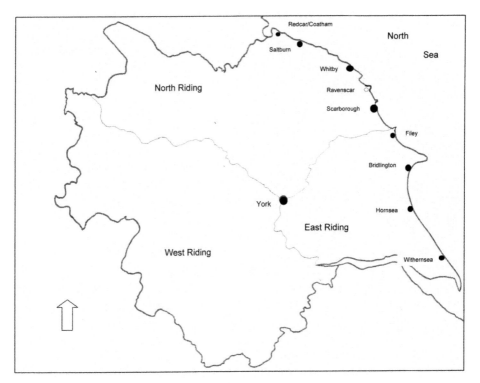

Yorkshire's coastal resorts in the nineteenth century.

from newspaper advertisements that Whitby and Bridlington Quay (as opposed to the town, a mile or so inland) were receiving visitors by the mid-eighteenth century.

From the beginning of the nineteenth century, and certainly after 1850, the number of people spending time at seaside resorts was rising. Several factors were at play. Two important ones were the rise in population generally, and also the numbers of families made wealthy by enterprise in commerce or industry. All pursued the therapeutic benefits of residing by the sea, or the social intercourse and entertainment to be found there. It also led to the growth of further resorts. On Yorkshire's coast this had begun before 1770 with Sir Charles Turner of Kirkleatham's promotion of East Coatham, near Redcar, although this was also a means of improving his estate. The nineteenth century was the real period of expansion. Filey, for instance, was beginning to be patronised by a select few in the early years of the nineteenth century, but an article of 14 April 1837 in the *Hull Packet* announced: 'FILEY BAY – Those who are acquainted with this delightful spot as a bathing place will learn with satisfaction that good roads and pleasing pleasure grounds are in a state of formation...'

The person responsible was John Wilkes Unett, a Birmingham lawyer who seems to have been assisted by his sons, John Jr and George – especially John, who was to inherit the Filey estate after his father's death in 1856. If Unett had embarked on

such a venture at the age of sixty-five, he nevertheless had considerable experience of developing estates near Birmingham at Sparkbrook and Smethick. He was already preparing plans by 1837, and what this brought into being was a superior development on the clifftops to the south of the old village of Filey, overlooking the sea and designed to cater for 'the quality'. 'New Filey' was largely completed by the 1860s and remained a successful and select resort until the beginning of the twentieth century.

As Filey was nearing completion, a further resort was being planned. Saltburn, on the coast of North Yorkshire, is remarkable in possessing some of the same characteristics as the model industrial villages that arose in the nineteenth century: paternalistic control, regulation of housing and building materials and limits on the sale of alcohol. This is in some ways unsurprising when we come to consider how the resort originated – as the *Leicester Chronicle* of 10 November 1879 put it, Saltburn had been 'selected by capitalists as the site of a watering place'. It was the brainchild of Henry Pease, one of a family of County Durham industrial magnates that dominated development along Teesside. At Saltburn, Pease was able to acquire an almost virgin site for a new resort, since there was little there except scattered farms and a fishing hamlet near the sea. By 1856, the Stockton & Darlington Railway – in which the Pease family had major interests – were already constructing lines in this area to exploit the Cleveland ironstone fields.

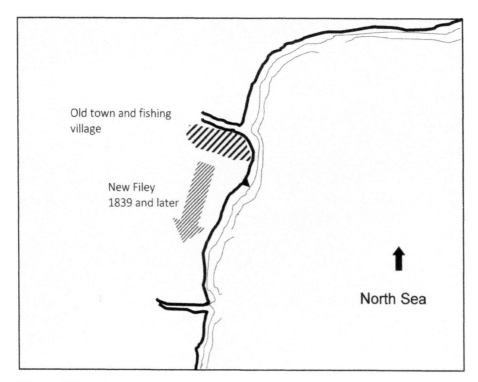

Filey and New Filey.

Saltburn's development as a resort was probably an addition to this railway extension. Pease was the driving force, establishing the Saltburn Improvement Company (SIC) in 1860, a body that had both the capital and the expertise to acquire and lay out land, much of it acquired from the Earl of Zetland. The result of this endeavour was a resort to the north facing the sea together with another area of houses to the south, the Zetland Hotel being a pivotal feature of the plan. The eastern fringes of the town were set aside for individually designed villas. If there seems a similarity between Saltburn and some other resort development, the major difference was in the planning and control exercised over building by the SIC to ensure a consistently high standard of housing.

Where resorts were already established, expansion tended to take place by the building of suburbs in small developments on vacant land around the edges of town. At Bridlington Quay this took place from the 1860s in several places, but especially at Beaconsfield, to the north. At Whitby a new suburb was planned in the 1840s on the West Cliff by George Hudson, 'the Railway King', until the collapse of the Hudson empire; development continued from the 1870s under Sir George Elliot. At Scarborough a development company – the South Cliff Company – began to lay out the Esplanade and make plots available on land to the south of the centre from the early 1840s; land to the north was similarly developed.

By the late nineteenth century, there were eight or nine resorts on the Yorkshire coast. These were Coatham/Redcar, Saltburn, Whitby, Scarborough, Filey, Bridlington Quay, Hornsea and Withernsea. They could not, however, all be considered of equal status, whether measured in size, reputation or social tone. Some, such as

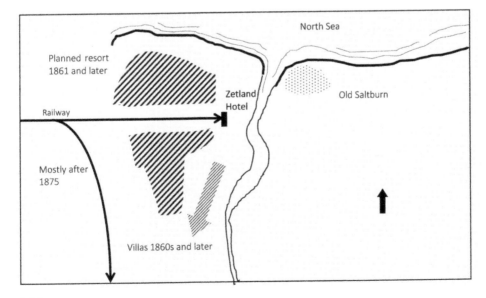

Saltburn.

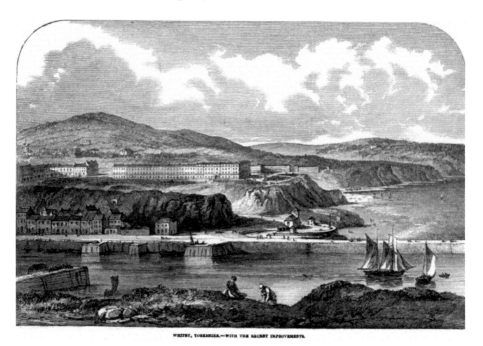

Whitby from the *Illustrated London News* in 1852, showing Hudson's proposed development of the West Cliff (middle ground).

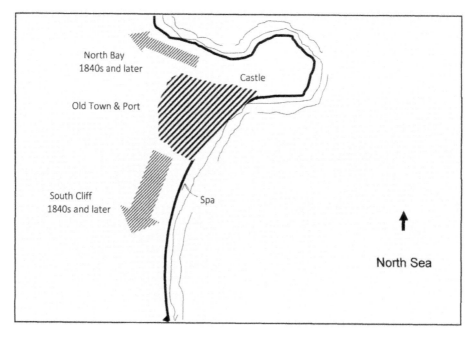

Scarborough's nineteenth-century development.

Hornsea and Coatham/Redcar had never developed to their full potential because of wrangling between individual developers or local authorities. When Pierre Henri Martin du Gillon, a French academic who had been teaching at colleges in Wakefield and Sheffield, put forward a plan to develop the southern part of Hornsea, it was blocked by the local magnate Joseph Armytage Wade. Constant bickering between the representatives of Coatham and Redcar seems to have obstructed the development of both places. Similarly, plans to develop Withernsea began hopefully: by the 1850s there was a railway branch to Hull, Cuthbert Brodrick's Queen's Hotel was built, and balls, attended by the region's landed families and others, were held to mark the beginning of the summer season. Further plans came to nothing. As the *Withernsea Chronicle* commented, 'plans which looked so elaborate on paper seem to have vanished into thin air.' Housing plots offered for sale seem to have had few takers, and those that did went to local builders, the result falling short of the unified plans proposed. Withernsea became more of a dormitory town for Hull.

The last serious attempt at creating a resort on the Yorkshire coast was Ravenscar, located at Peak or Raven Hill to the north of Scarborough. Here, Raven Hall, had been acquired as a summer home by William Henry Hammond, a land agent of Highbury Hill, Middlesex. In the decade after his death in 1885, the estate came into the hands of the Peak Estate Company Ltd. This company drew up plans for a totally new resort at Peak on cliffs looking onto the North Sea to the east and with the North York Moors inland to the west. In July 1896, the

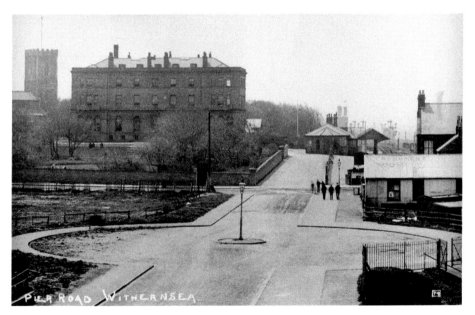

Withernsea, Pier Road. A grand avenue leading from Brodrick's Queen's Hotel (background) to the pier. It was to be a principal entrance to the town from the railway station. The road was laid out, but the surroundings were not completed.

Daily Gazette for Middlesbrough could report that the company was transforming the old house into a hotel, and plots were laid out to create 'a first-class watering place'. The venture started well with forty-one of seventy-nine plots offered for sale being sold at auction. Further auctions took place. Developments were afoot: a new hotel was completed, the old house being extended in the 1890s by the Scarborough architect Frank Tugwell, and a golf link was opened with Lord Cranbrooke as club president. Yet by 1900 very few buildings had materialised, and the *Leeds Mercury* reported in May that a further auction 'found speculators in little mood to buy' – only nine of the 102 plots offered were sold. In 1911, the company went into receivership and no further development took place.

Despite the failures, one might well ask what sort of a pecking order Yorkshire's resorts occupied. Scarborough, the largest, was undoubtedly the resort most favoured. Its tradition of catering for elite society for over a hundred years or more was probably the factor that ensured this and seems to have been the presumption on which the South Cliff Company and building speculators operated. Thus, plans drawn up for villas and terraces on South Cliff assumed the presence of servants by making provision for servants' rooms; many houses had stables also.

There was no other Yorkshire resort that could compete with Scarborough, not even Bridlington Quay, Scarborough's largest neighbour. While Bridlington Quay may have begun the nineteenth century confidently and established facilities such as assembly rooms and therapeutic baths, this progress was not maintained, the beau monde preferring Scarborough. Whitby, however, found more favour. Despite

The Crescent at its junction with Hammond Road, Ravenscar. Streets were laid out, but 'speculators were in little mood to buy'.

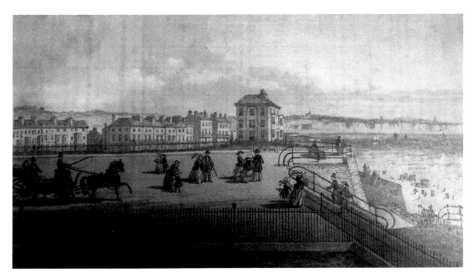

Bridlington Quay – a rare view of the Esplanade (after 1854). The central house is Fort Hall. (East Riding of Yorkshire Museums Service)

its sometimes being described as difficult of access, Whitby did attract elite visitors and, with the resumption of development on the West Cliff, continued this trend. In the season, Whitby might be regarded as a superior sort of a resort. The same could be said of Filey, and what attracted people was probably two things: its location and the social tone of the town. Filey could offer dramatic scenery and a fine beach; it was serene, but close enough to Scarborough for entertainment, if desired. It is no exaggeration to say that keeping 'incursions of noisy excursionists' at bay was a desired aim, expressed in no uncertain terms in proposals to extend Filey in 1894. What amounted to almost a further new resort was to be built on cliffs to the north: 'It must become more fashionable, and some people, no doubt, will regret this change,' reported the *Leeds Mercury* in August 1894, but 'nothing is to be done to disturb the quietude of the place: the tripper will be discouraged at all points'.

These places topped the hierarchy of Yorkshire coastal resorts. Those in the middle reaches were marked not so much by an absence of elite visitors as a dominance by commercial and industrial families who either retired there or commuted from them to their places of business. Hornsea, for example, became a place of residence for Hull business families; Saltburn for families from Middlesbrough or County Durham. Redcar ought to fall into this category, but stagnated to become a straggling street along a seafront composed largely of lodging houses and small hotels, which did not attract the higher end of the market. It was characterised by one contemporary journalist as Saltburn's 'busy *bourgeois* neighbour', a resort that appealed to 'comfortably-placed shopkeepers for their summer and autumnal outing'.

So, what kinds of visitors did Yorkshire's resorts attract? This is the subject of the next chapter.

2

The Visitors

We all know what an elite is, don't we? A number of expressions are used to describe its members, many of them in use in Victorian Britain – toffs, nobs, the quality, fashionable society, and so on. Yet since the subject of this book is how elite society spent its time at the seaside then a more precise description is in order – and there is a contemporary one: 'the Upper Ten'. It was short for 'the Upper Ten Thousand', implying the top ten thousand most influential and wealthy people. By 1875 it could be said to have a better definition when the publisher, Kelly's, brought out its directory of the *Upper Ten Thousand*, a work that went through several editions and which by the 1880s was entitled *Kelly's Handbook to the Titled, Landed, and Official Classes*. The population of Britain when Kelly's *Upper Ten Thousand* was first published was between thirty-one and thirty-five million, so the Upper Ten would have represented a fraction of 1 per cent. Yet the term Upper Ten was probably never intended to be an accurate measure, more of an indication of the prosperity and status of a tiny proportion of the population. Kelly's was probably the first publication to attempt such a classification, going further than previous directories of county families or genealogies like Burke's *Peerage*, in the range of people it listed. It contained a ranking of individuals that began with the royal family and included nobility, Members of Parliament, colonial administrators, the higher professions, industrialists and bankers. As Kelly's boasted in the preface, it contained 'twice as many names of living persons' as other similar publications.

Exactly how the selection was made is unclear, but it was one that did not discriminate in terms of profession, class or gender: earls and industrialists kept company with wealthy women and politicians. The same sorts of people appear at Yorkshire resorts in visitor lists, newspaper reports, or family letters and diaries. The heiress Elinor Clarke was to build a new house in Filey, where she had been reckoned the richest woman living there in the late nineteenth century; Henry Labouchere or 'Labby', banker, journalist and celebrated politician, stayed at the Grand in Scarborough, where Lord Londesborough also had a seaside house; the Marchioness of Lothian on the other hand, preferred Whitby; while the Bradford textile magnate Angus Holden and his family holidayed in Bridlington in 1875. All came from families associated with the Upper Ten, or were part of a wealthy and authoritative upper crust. Nor was it only in the pages of Kelly's that they became

neighbours, there was a physical reality to this. In West Street, Scarborough, in 1885, the Feilden family, Lancashire cotton manufacturers, lived across the road from Sir J. C. Cowell of the Garter House, Windsor Castle, Master of the Queen's Household. The Dowager Duchess of Argyll was staying at the Royal Hotel, Whitby, in September of 1872; her fellow guests included the Dean of Windsor and Charles Hadfield, a Sheffield architect; while over at the Angel Inn Lord and Lady Congleton and their daughter, the Hon. Cecilia Parnell had the Tetley family, textile merchants of Bradford, for company.

Such elevated positions rested in part on wealth, but how much did it take to be thought rich in Victorian Britain? The historian W. D. Rubinstein has put forward the proposal that the very rich were those who left £500,000 and upwards at the time of their deaths. He also marked a lower scale of wealth at £100,000 and above. These people were rare and, to many, possessed wealth beyond dreams – leaving even £50,000 at death would have put you hugely above average means. A position among the elite, however, was not solely dependent on wealth. William McLagan, for instance, was the son of a Scottish physician who, on his death in 1910, left personal effects valued at £17,541, placing him well down, even outside, this wealth scale. He was, however, the Archbishop of York, a position carrying immense social prestige, locating him amongst the higher social ranks. In this sense, too, we might include members of the traditional professions – the Church, the law, medicine, the armed forces – who were owed social honour, since their specialised knowledge and expertise gave them an authority in pressing matters of life, death and justice. Also, there were those musicians, artists and entertainers to whom the elite extended its embrace. Celebrities in their day, some of them are still remembered: Jenny Lind, for example, or the artist Atkinson Grimshaw, whose patron the Rotherham brewer Thomas Jarvis retired to Scarborough, providing Grimshaw with a studio there. But who has heard of Meyer Lutz? Lutz was a composer of light operas and musical director of the Gaiety Theatre, London, who also toured Yorkshire resorts in the season.

These rich and distinguished persons came from across Britain to stay on the Yorkshire coast. They came in increasing numbers after the mid-nineteenth century, a surprising amount of them from London. Nor were such visitors confined to Britain, for Scarborough and Whitby had many visitors from overseas – the USA, South America, France, the Netherlands, Belgium, Spain, Germany, to name but some. Others came from parts of the British Empire, returning, perhaps, to visit family and holiday in the mother country. But these were no minions, for some were high-ranking military officers or highly placed administrators, like Joseph Alexander Dorin who had been one of the four members of Lord Dalhousie's council, which had become the executive of the government of India. Dorin lived for a while at Allfield, Scarborough, with his fourteen servants – perhaps the largest servant household in the town. The list of notable visitors would also have to include foreign politicians such as Constantin Kretzulescu, academic and

former prime minister of Rumania; the members of European royal families such as Austria, France and Belgium; and British royals – Edward Prince of Wales, Prince George, the Duke of Cambridge, Queen Victoria's cousin, or the Grand Duke of Hesse and the Battenbergs, who were related by marriage to the British royal family.

The impression is sometimes given that Yorkshire resorts in the nineteenth century were the locations of sedate middle-class holidays. Another view proposes that it was mostly the new money of the West Riding that holidayed on the Yorkshire coast. Both views are in need of revision. Such opinions had probably begun to take hold in the early nineteenth century, a reaction, perhaps, against what were seen by some as vulgar, upstart Yorkshire manufacturers who had time and money to holiday but lacked breeding. It is well exhibited by Catherine Hutton, the daughter of a Birmingham paper merchant and antiquary who, while staying at Scarborough in 1806, wrote to her father: 'Though the company is more numerous, I think it is, upon the whole, less desirable; the additions being chiefly cloth-makers and merchants from the West Riding.' The myth has been perpetuated by some twentieth-century historians also, one describing Scarborough in the nineteenth century as becoming 'colonized' by Leeds and Bradford businessmen.

While it may be true that middle-class families comprised the majority of visitors to Yorkshire resorts, what characterised places such as Filey, Whitby and especially Scarborough were the numbers of wealthy and eminent families from across Britain. It was this upper section of society that was wooed by developers and hoteliers, and with some success. It left some middle-class visitors and commentators flabbergasted by the people they encountered. Thus, in 1867 the Methodist minister George Shaw could write in his book *Rambles About Filey* that he had personally seen 'Earl Russell, Cardinal Wiseman and the Archbishop of York in one day'; and an article in *The Architect* of February 1874, suggested that Whitby was 'reserved for the "upper ten Thousand"'. The best description of fashionable society at play is that which appeared in *The Builder* in 1861. In a description of Scarborough's architectural development, its author digresses, noting that 5,000 visitors a week could be expected in the season; it was a resort chosen by the 'beau monde', and that:

> By far the greater number of visitors come from London. After the Metropolis, Manchester and Leeds are the next contributors to the throng; then come Hull, Huddersfield, Bradford, York, Sheffield, and other large Yorkshire towns. Newcastle is represented; so are Birmingham and Wolverhampton: even Cheltenham is quitted for Scarborough; so is Royal Windsor … Other groups on the Spa promenade come from Edinburgh, Dublin, New York, Madras…

The article concludes that Scarborough is 'a kaleidoscopic view of wealth holiday making'.

Places of entertainment, second houses by the sea and luxury hotels arose in response to this social scene in which wealth, health and leisure together with the opportunity to see and be seen were important factors. The chapters that follow explore the activities in which this wealthy throng took part and how they were expressed architecturally.

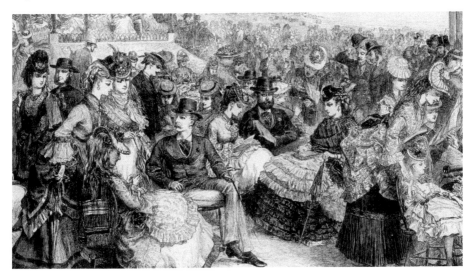

The Spa Promenade, *Illustrated London News,* 1871. The subjects cannot be identified, but they do not look like the working class on a day trip.

3

Homes by the Sea

Large houses built near the sea for an elite were nothing new in the nineteenth century. Some houses, the seats of nobility and gentry, had been in such settings for generations. These were not, however, second homes chosen for their seaside locations or places to which families might retire, but country houses handed down through generations. Yet even on established coastal estates, or others a little farther inland, a growing appreciation of the sea view prompted some families to build prospect towers from which a glimpse of the sea might be enjoyed. At Boynton Hall near Bridlington Quay, the Strickland family built the Temple of Aeolus on a high point of their grounds at Carnaby, a tower from which the view extended over Bridlington Bay; Joseph Storr, a member of a gentry family of Hilston in the East Riding, built the Mount, an octagonal brick prospect tower around 1750 on

Carnaby Temple, near Bridlington. Originally called the Temple of Aeolus, it had a balcony around the first floor giving sea views.

rising ground near the village. Although above a mile inland, Charles Turner had erected a temple on high ground near his house at Kirkleatham. From it there was 'a most noble prospect ... bounded by the sea and the river Tees'.[1]

By the later eighteenth century some gentlemen were also building second homes or retreats on the coast at Bridlington Quay and Scarborough, as well as in more isolated positions. Hilderthorpe House at Flat Top, Hilderthorpe, was built for Christopher Sykes around 1776, giving views towards Bridlington Bay. Grimston Garth was designed in the 1780s by John Carr for Thomas Grimston of Kilnwick-on-the-Wolds. It stood on the coast south of Aldbrough, offering seclusion as well as views across the sea. In perhaps the 1830s, Richard Oliver Gascoign, a member of a landed family with estates at Parlington near Leeds, had built South Cliff Villas at Filey. At Bridlington Quay Henry Boynton of Burton Agnes Hall had remodelled two houses in Prospect Street (now Manor Street), around 1820 to serve as his town house.[2] At Scarborough it is sometimes unclear as to whether families owned or were lodging at houses. The Duke of Devonshire, for example, may have owned a house on St Nicholas Cliff, or simply taken one for the season, but the Cayleys of Brompton-on-Sawdon had possessed a house at Scarborough from at least the 1750s, and the *Morning Post* in August 1827 implied that the 'splendid mansion on the Cliff' was owned by Diana Beaumont of Bretton Hall in the West Riding. All of these houses belonged to landed families, but running parallel to these developments were the houses being built on the proceeds of commercial or industrial enterprise. At Bridlington, John Walker had built Fort Hall to the north of the quay around 1792. William Voase, a Hull wine merchant and shipowner, built North Cliff Villa at Filey around 1830, and Henry Bentley, a brewer from the Leeds district, had built Ravine Villa there by 1837. At Scarborough, villas had begun to appear in the Crescent by 1830–40, such as Wood End, possibly J. B. and W. Atkinson for George Knowles, himself an architect and surveyor.

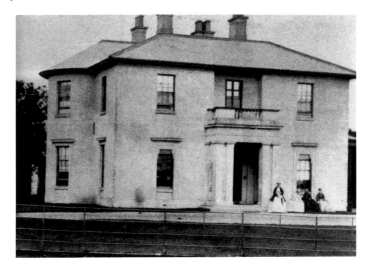

Filey, an early photograph of Ravine Villa (demolished). (FTC Crimlisk Fisher Archive)

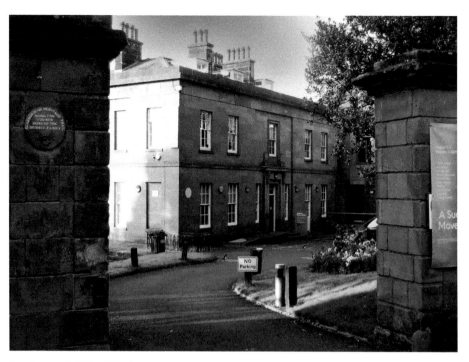

Scarborough, Wood End.

All of these houses were designed in styles redolent of the traditions of the previous century, whether austere neoclassical or Gothic, although not the Gothic of the Victorian era. Raven Hall combines both and provides an example of the sort of isolated residence on the coast that some elite families found desirable. It was built between 1835 and 1840 by Revd Dr Richard Child Willis, and stands on a high cliff overlooking Robin Hood's Bay at Ravenscar, or Peak as the area was generally known before the 1890s. Child Willis was educated at Oxford and like his forebears became an Anglican clergyman, being ordained in 1823. After his mother's death in 1835, however, he inherited Peak and other property, thus enabling him to refashion the estate. This entailed rebuilding an earlier house on the site – Peak or Ravenhill Hall – and also laying out gardens near the cliff, enclosing them with 'castle' walls.

William White's directory of 1840 states that Raven Hall was built in 1837. This tends to confirm the passage in Meadley describing the house as nearing completion in 1836.[3] Meadley also adds that the architect was John Barry of Scarborough. What Barry designed was an austerely neoclassical house, a style that had more in common with designs of the first quarter of the century. Built of ashlar, the principal elevation to the west was devoid of ornament, but had a pair of two-storey bay windows taking up much of this front and set equidistantly across it. Entrance to the house is through a similarly severe porch in the south elevation. The result is arresting, but bleak. Advertisements for the sale of

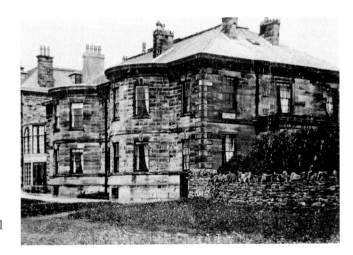

Ravenscar, Raven Hall
(early postcard).

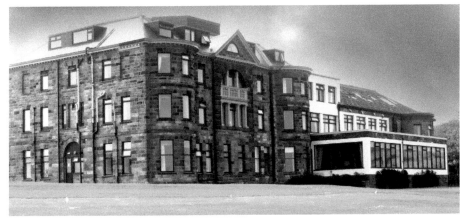

Above:
Raven Hall
today. Frank
A. Tugwell's
hotel extension
of *c.* 1896 is in
the foreground.

Right: Raven
Hall was also
laid out with
garden terraces
on the edge
of the cliffs
enclosed by
castellated
walls.

the house in the 1840s suggest a luxurious interior with 'nearly new' furniture manufactured by 'two eminent London Upholsterers'[4] for what was described as a 'Magnificent Marine Mansion'.[5] Little of the well-appointed detail this implies has survived after conversion to a hotel in the 1890s except for a sinuous staircase leading to the first floor.

This style of architecture was already outdated when Sir William Lowthrop – one of the commercial magnates of Hull – built a villa on South Cliff, Scarborough, between 1841 and 1845. This is a significant house, because it was probably the first Victorian Gothic villa built on the Scarborough seafront. Alga House (Latin, *alga* – seaweed), as the villa was known, sits prominently, but uncomfortably, between suave classical terraces to either side. The architect is unknown. Further Gothic or Tudor villas by the sea were beginning to emerge around this time. At Marske-by-the-Sea Joseph Pease, the County Durham industrialist, had built Cliff House as a summer residence on the edge of the village overlooking the sea. Cliff House is a competent design of around 1845 in the sort of Elizabethan style that some contemporary commentators associated with the English country gentleman, although Joseph's father, Edward, did not approve of its extravagance which did not accord with his Quaker principles. Other houses were more rugged and might be influenced by location. The Towers, Scarborough, was designed for

Scarborough, Alga House.

Marske, Cliff House (John Middleton, attrib., *c.* 1845).

the Rotherham brewer Thomas Jarvis by William Baldwin Stewart in 1866. It was no doubt intended to echo Scarborough Castle, below which it stands, having a central range between two muscular, castellated towers, a well-tried configuration Stewart also used for the gateway to Scarborough gaol, which he designed in the same year. Adjoining it is a further castellated house occupied in the 1870s by the

Scarborough, The Towers.

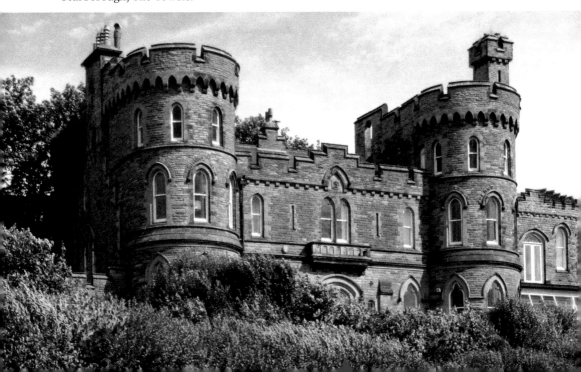

painter Atkinson Grimshaw – Jarvis was a patron of Grimshaw. *The Architect*, however, proved rather sniffy. In its review of Scarborough's architecture for its February 1874 edition, the Towers was described as 'a featherbed fortalice' set within 'the very precincts of the grand old Norman castle of Scarborough'. Other Gothic villas in Scarborough proved more complex. Moseley Lodge, Westbourne Grove, was built for the Webb family, bankers of Stafford, probably in the early

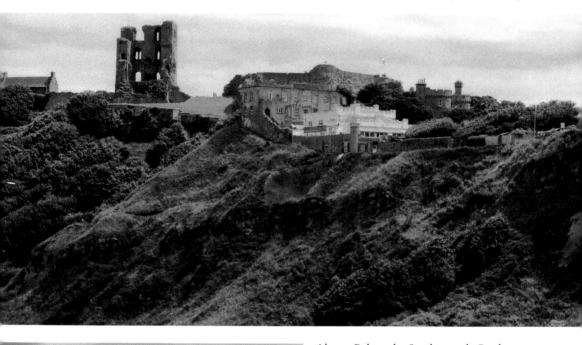

Above: Below the Scarborough Castle site, Castle-by-the-Sea.

Left: A guerite or sentry box at Castle-by-the-Sea – perhaps used as a gazebo?

1870s, in an eclectic style – an array of Tudor windows, but an entrance tower clearly showing French influence.

Gothic was not the only villa style. Other houses were built in new classical styles, influenced by Renaissance Italy or Second Empire France. Hornsea supplies examples of Italianate villas appearing in Westgate and Eastgate in the 1860s and 1870s, mostly for Hull business families. The same sort of development can be found at Scarborough, but in greater variety. Westwood House was built in probably the late 1850s for the York brewer and banker Edward H. Newton, in a rural Italianate style with simple detailing, its grouping of forms incorporating a campanile-like tower. Such designs seem modest when compared with some of the lofty French-inspired villas that appeared around the same time. Standing three storeys high with attics and basements, The Wick and Allfield House, Scarborough, possess deep eaves-cornices, balconies and Mansard roofs. Their first occupants seem to have been the Earl and Countess Cathcart in The Wick, and in Allfield House, Joseph Dorin, former member of the executive committee of India. Other Italianate villas followed throughout the 1860s and into the 1870s. Bridlington, too, had its share of the Italianate, such as the house designed in 1878 by Joseph Earnshaw for William Nicholson, a Sheffield steel maker. This tall two-storeyed detached villa has two gables in its elevation creating a narrow entrance in an otherwise competent Italianate composition.

Farther along the coast at Saltburn villas of mostly Gothic designs were appearing in the 1870s along Glenside, forming an elite enclave. They tended to be occupied by commercial and manufacturing families of Teesside and County

Above left: Scarborough, Moseley Lodge.

Above right: Scarborough, Westwood House.

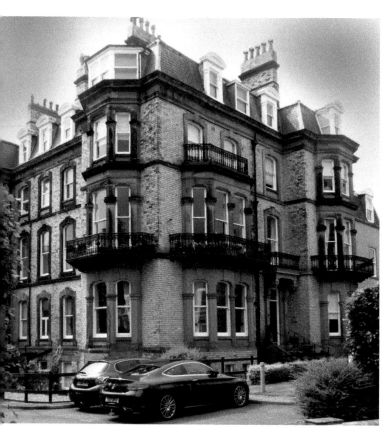

Left: Scarborough, Allfield House.

Below left: Bridlington, Wellington Road (Joseph Earnshaw, 1878).

Below right: The ends of some terraces could be orientated to form a 'villa' by placing the entrance in the gable, as at the Crescent, Filey.

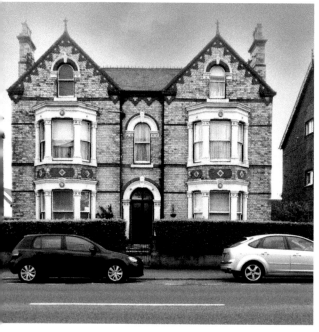

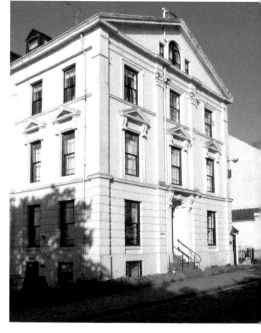

Durham, a development that becomes common on the more northerly parts of the Yorkshire coast. Several large villas were built here, drawing in stellar names of the architectural firmament. Overdene, for example, was built for William Whitwell of Thornaby Ironworks between 1874 and 1876 to a design by Alfred Waterhouse. Whitwell's near neighbour was William Walker, another ironfounder of Redcar. Riftswood was built for him in probably the 1880s, a full-bodied villa in red brick, but with curvilinear gables and Queen Anne detailing.

Foremost among the Saltburn houses is Rushpool Hall, the home of John Bell, a member of one of the industrial dynasties of the North East. It dates from between 1863 and 1865, and became Bell's principal residence, representing perhaps a haven from the industrial sprawl of Teesside. Standing to the south of Saltburn above Skelton Beck, its design seems to draw on the chateaux of the Loire, but abandoning Renaissance detail in favour of the Gothic of Venice. The interiors, too, seem to have had a majestic architectural quality, although this can only be judged now from photographs taken after a disastrous fire in 1904.

Local historians have attributed the design to Sir George Gilbert Scott, although none of Scott's biographers list Rushpool Hall among his works, nor did any

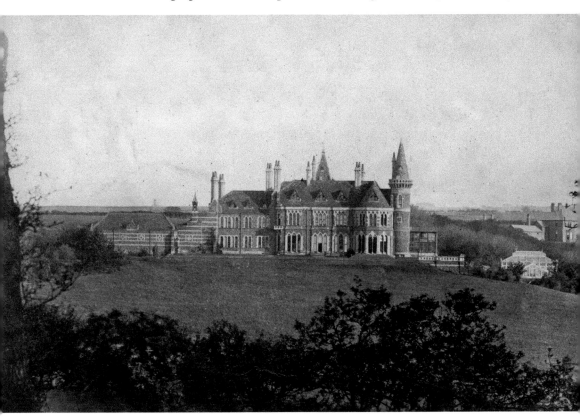

Saltburn's Rushpool Hall from an early photograph (possibly from the 1870s). Note the winter garden to the lower right. (RIBA Collections)

contemporary comment appear in the architectural press. However, an article in *The Architect*, of 24 February 1872, tantalisingly refers to Rushpool as 'having been designed by an eminent man in the profession'. Whoever the architect was, Rushpool Hall is the outstanding Victorian Gothic house to have been built on the Yorkshire coast, and too important to be ignored, yet it is neither a country house nor a villa by the sea. It is one of a small number of houses built a little inland from the coast, usually by industrialists, as if their desire was to enjoy the benefits of the sea combined with country living. Others include Wrea Head, north of Scarborough (John Edward Ellis, railways and mining), Dunsley Hall, near Whitby (George Haigh Pyman, shipping), or Killerby Hall, near Cayton Bay (James Cooper, textiles).

By the later nineteenth century, architectural styles were to develop further. It is probably correct to say that two broad categories of style for domestic architecture were to emerge: classical revivals and vernacular revivals. Both were reconstructions of earlier styles; both looked backwards to look forward in the way that they combined features of different periods, yet retained an overall appearance of either the classical or vernacular; and both laid an emphasis on craftsmanship. The classical revival had perhaps begun with what was called by contemporaries Queen Anne – which had little to do with the Queen Anne period. It was a classicism that could be combined with half-timbering or shaped gables, as well as white-painted, small-paned sash windows which were a feature of many such designs. It probably first appeared on the Yorkshire coast at Coatham around 1868 where the industrialist Thomas Hugh Bell commissioned Philip Webb to design Red Barns. Webb's initial design was for a modest red-brick villa, plainly detailed with steep, tiled roofs and small-paned sash windows. It is in the Scarborough of the late nineteenth century, however, that mature examples of classical revival styles can be found and on an extensive scale. Granville Road, for instance, appears to have been planned and designed in the 1880s largely by the Robsons, architects and builders, including the house occupied by the Bradford textile merchant George Bankart. Mount Priory, as the house was known, is a confidently handled composition in buff and red brick.

Probably the finest classical revival house hereabouts was built for the York solicitor John Henry Turner. Dunollie, on Filey Road, was designed by the York practice of Penty and Penty in 1901. Constructed of red brick with stone detailing, it is designed as if a hall and cross-wing manor house of earlier centuries had been remodelled in the eighteenth century, retaining some of its earlier features among the wealth of new classical work, its open baronial hall and gallery contrasting with the plasterwork ceilings and classical fireplaces of rooms in other parts of the house.

Scarborough was not the only Yorkshire resort to indulge itself in this way. The Nook on the southern edge of New Filey has tile-hung gables and stone dressings to the entrance, which combine in a small but delightful Queen Anne villa. Queen Anne also influenced designs of houses at Bridlington Quay, such as

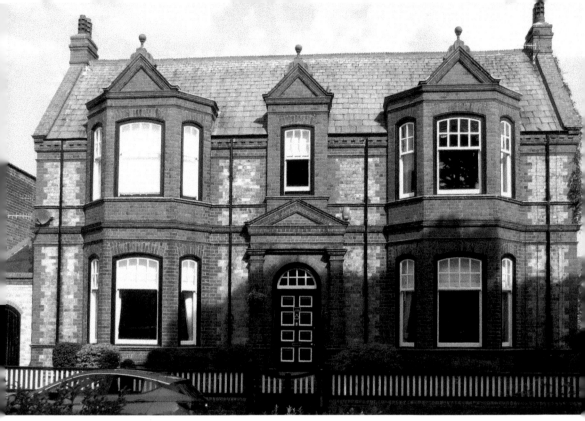

Above: Scarborough, Mount Priory.

Right: Scarborough Dunollie (Penty & Penty, 1901).

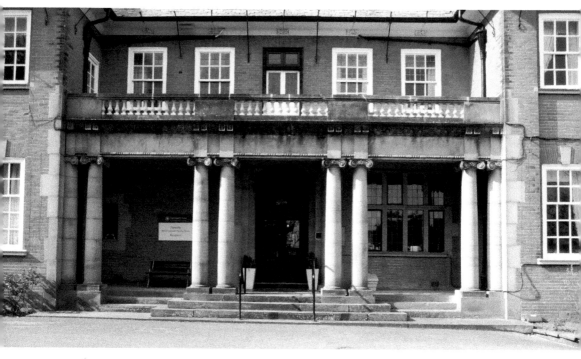

The entrance – restored after shell damage in 1914.

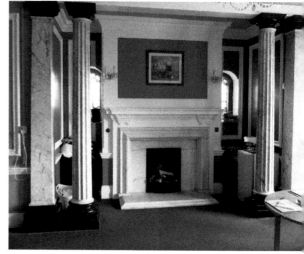

Left: The hall gives the impression of an earlier baronial hall, contrasting with…

Above: …the classically designed dining room.

Turmer House in Canton Villas, built around 1893–94 for William Todd, an East Riding gentleman. Although basically a large villa in red brick, applied decorative panels, ball finials and steep pediments to some windows give it a more showily classical air.

Running contrary to classical revivals were designs based on traditional or vernacular forms typified by the small manor house of the seventeenth century, a style sometimes called 'Old English' by contemporaries. Such houses usually contain luxurious interiors with an attention to craftsmanship and reinterpretations of traditional detail. At Scarborough, at the southern end of the Esplanade, is Brackencliffe, designed for the York dentist Walter Glaisby by Walter Brierley in 1905. Brackencliff displays well the qualities associated with vernacular revival architecture in its detail, materials and form, yet all employed in the creation of a modern house. At Bridlington Quay the Beverley lawyer James Mills had built a *pied-a-mer* at the end of Windsor Crescent in 1881, probably giving a view to the sea originally. The house was designed by Smith and Brodrick of Hull with a Tudor-ish brick ground floor and half-timbered upper storey, but it must have been Mills who gave it the name 'Villa Bella'.[6] More progressive developments were taking place at Flamborough, where The Cliffe was built

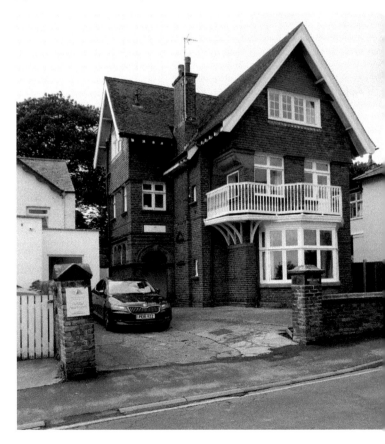

Filey, The Nook.

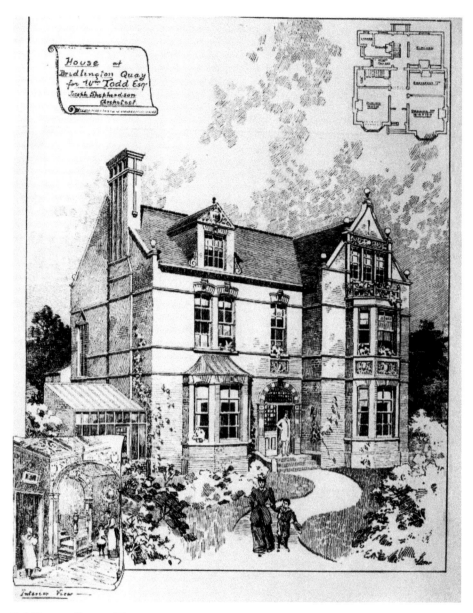

Bridlington, Turmer House.

by Elizabeth Marsden and Louisa Melly, two women of independent means that rested on commercial and industrial wealth. Marsden, it would seem, had approached Cooper, Hall and Davies of Scarborough in 1895 or 1896 to design the house.[7] Originally to be called South Sea House, it became known later as simply The Cliffe. What they produced was a long, low, stone house, its interiors panelled and with a gargantuan fireplace in the dining room. Yet, for all that, the

Above: Bridlington, Villa Bella (Smith & Brodrick, 1881).

Below: Flamborough, The Cliffe.

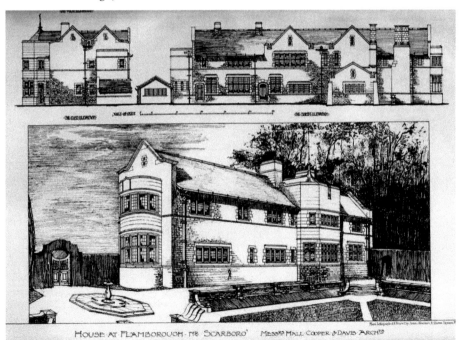

house possesses the sort of intimate quality present in many vernacular revival designs.

Other houses similarly exhibit these qualities. North Cliff, Filey, stands on the site of one the town's first seaside houses, a modest villa that was dismantled and replaced on a proud scale. Brierley was the architect, and what he produced for his client Elinor Clarke in 1890–91 was a conventional enough vernacular revival design. What lifts it out of the conventional is the incorporation of an east-facing tower that rises through three storeys. North Cliff gives the appearance of a Jacobean manor house rebuilt from an earlier one, of which only the defensive tower remains. It became not only the most original, but also the largest house in Filey, with grounds sweeping down to the foreshore road where a freestanding winter garden was located. Brierley and the house also gained a certain international airing, figuring in *Das englische Haus* by Hermann Muthesius, architect and German Cultural Attaché, published in Berlin in 1904/05.

Brierley was not the only architect of note to have worked along the Yorkshire coast in the later nineteenth century. At the Royal Academy's architectural exhibition of 1878, the London-based architect J. D. Sedding exhibited his design for a house at Wheatcroft, south of Scarborough. His client was the lawyer and businessman G. A. Smith, and Wheatcroft Cliff, as the house became known, also featured in the May and June editions of *The*

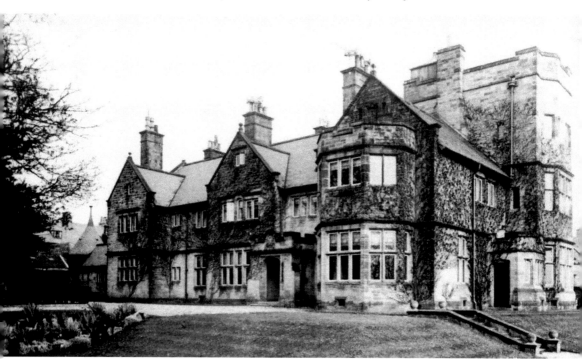

Filey, North Cliff (Walter H. Brierley, 1891).

Right: The tower lends drama to the composition.

Below: Elinor Clarke's opulently furnished drawing room. (Brierley Groom, Architects)

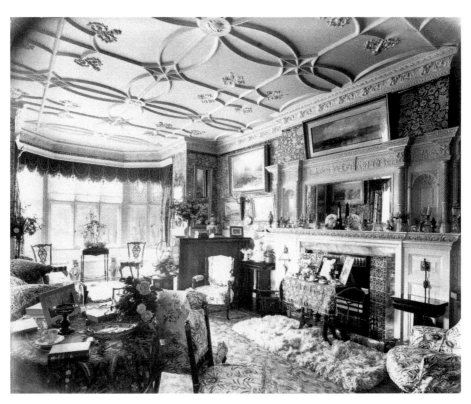

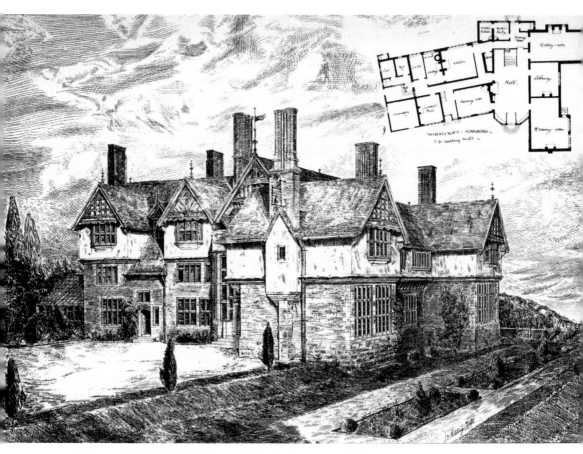

Wheatcroft Cliff (J. D. Sedding 1878) – 'rather too quaint'.

Building News. Described as 'a charming house' in the 'Old English' manner, the reviewer, nevertheless, found it 'rather too quaint' for his taste. Built on a grand scale, it later became the Holbeck Hall Hotel, destroyed by a landslip in 1993.

Not all designs of house of the nineteenth century fit easily into the categories defined above. Some seem more artistically conceived, if on a suburban scale. Two in Scarborough illustrate the point well. In 1864, J. and D. Petch had designed the villa that became known as Stamford House, which was acquired by the Leeds felt and carpet manufacturer John Wilkinson.[8] It is a large, detached house more than a little influenced by the Gothic of Venice in its cusped ogee windows on the ground floor, perhaps borrowing from illustrations in Ruskin's *Stones of Venice*. It is an ambitious design and there is little to match this in the mid-century domestic architecture of Scarborough, but whether it succeeds is open to question. A further house to exhibit this sort of aesthetic approach is Red Court, on the Esplanade, built to the designs of Bedford and Kitson around 1904–05 for Frederick William Tannet-Walker, head of a Leeds engineering

company. What they created was a suburban castle with four multangular corner towers, castellation above the eaves, and a wide main entrance that gives the impression it should hold a portcullis. Yet at the same time the original rear courtyard contained a garden with a columned palm house that added a touch of Italy, while its red-brick walls and tall, white-painted sash windows seem a glance in the direction of Queen Anne. It is an unusual design that exemplifies

Right: Stamford House, Scarborough: Venice hemmed in by later development.

Below: Red Court, Scarborough.

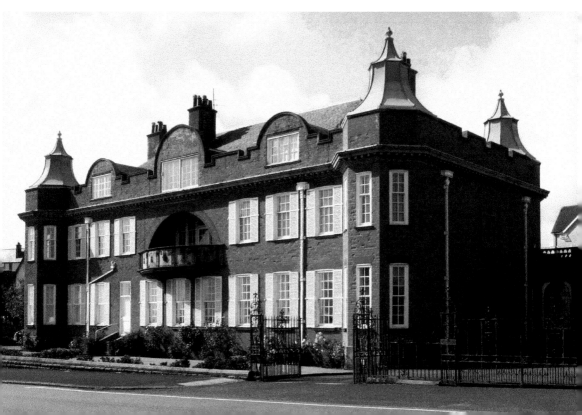

the eclecticism of what might be thought of as the more advanced or artistic practices such as Bedford and Kitson.

Arranging the House: Planning and Rooms

A key question for Victorian architects was the arrangement of rooms. Upstairs rooms presented little problem, since in detached houses they were mostly bedchambers, with servants' rooms usually in the attics. The issue for Victorian architects was the ground floor and the relationship between the drawing room, where guests and family might gather before dinner, and the dining room, to which guests might be formally escorted on what should be a well-thought-out dinner route. Some secondary residences in the seaside resorts were designed with just this minimum of rooms, such as the Gothic villa designed in 1862 by W. B. Stewart in Folly Lane, Scarborough, for Sir Alexander Campbell.[9] On the ground floor a drawing room and dining room to the south were separated by a hall from service rooms to the north. The same was true of Tyersall House, Bridlington Quay, designed for the retired Bradford wool merchant George Butterfield around 1872, and which contained simply a hall, dining room and drawing room.

But second homes or retirement homes of some elite families might be grander and possess a greater variety of rooms, including morning rooms, breakfast rooms, libraries, billiard rooms, boudoirs (women's private rooms) or studies, not forgetting the hall. With the exception of one or two very large houses, the majority of Yorkshire coastal homes seem to have been planned around no more than three to five ground-floor rooms. One room that does not seem to have been included in these houses, yet commonly occurs in urban or even country houses, is the business room where estate or other business might be transacted and documents kept. Here is perhaps the significant difference that was reflected in the plan: as secondary residences or places for retirement, coastal homes were intended for leisure and not business. One of the few exceptions was possibly 'Dunollie'. Its ground-floor plan contained a study close to the main entrance suggesting that this may have been more of a reception room for legal clients, hiving them off before access to private family rooms.

Villas by the sea seem to have been little different from houses built inland for elite families. Architects of local or national distinction were engaged; the same stylistic development occurred; and the same rooms were present together with servants' and service rooms. In other words, in both style and plan they appear to represent a continuation of elite life and its conventions, but by the sea.

4

New Streets

As visitor numbers grew at the older-established resorts, complaint was frequently made about a shortage of accommodation. Little rebuilding or expansion of central areas of streets took place, however, in either the eighteenth or nineteenth centuries, although in places some houses were built or rebuilt to superior standards. This took place in Scarborough along Merchants' Row, and in Whitby in parts of Haggersgate to provide further lodgings (see Chapter 5). A more common way of dealing with this problem was to expand resorts into areas of land close to town centres, often by adding small, planned units of terraces. A number of these developments are highlighted in this chapter.

The Crescent, Scarborough

New houses for the accommodation of the quality had been built on land around St Nicholas Cliff, Scarborough, from the late 1760s. In the 1830s, however, the Scarborough architect and builder John Barry, together with a young lawyer, John Uppleby, published a scheme for a crescent of houses and a number of villas to be built to the south of St Nicholas Cliff. Barry seems to have acted as builder and supervisor of the development, the architect being probably Richard Hey Sharp of York.[10] The scheme, illustrated in an architectural perspective published in 1832, consisted of a crescent of houses in two sections. Houses to the north – a terrace, really – were completed probably by 1835–37, but the southern section, the crescent proper, was not complete until the 1850s. If Sharp was responsible, then he seems to have brought a new standard to the area in the design of terraced houses. The earlier houses built on St Nicholas Cliff in the 1760s, while pleasing Georgian designs, seem a more piecemeal building of conventional detached and semi-detached houses joined together in a row with differing rooflines.[11] The Crescent houses, however, display a cool conformity in their frontages, faced in ashlar, sleek, but with slim surrounds to doorways – only the terminating blocks have further ornamentation. The Crescent was an innovation that brought a touch of metropolitan hauteur to Scarborough. It was also part of a larger scheme planned around private gardens. In this sense it emulates Bath and set a county-wide precedent. Other terraces in this area of Scarborough followed in its

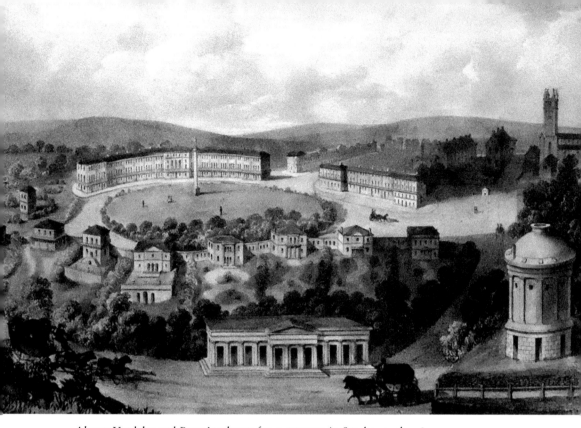

Above: Uppleby and Barry's scheme for a crescent in Scarborough, 1832.

Below: The Crescent was completed in the 1850s (R. H. Sharp?).

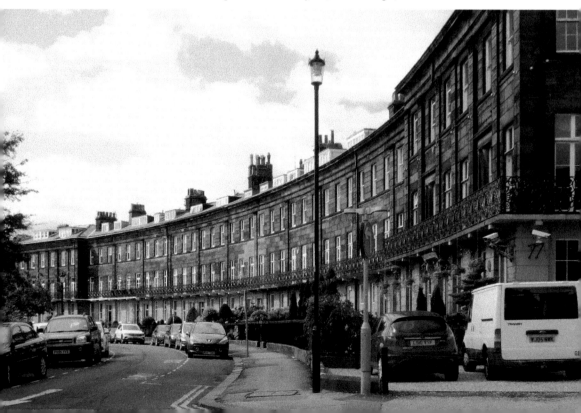

Above left and above right: The end houses of the terrace have greater detailing than inner houses, which only have shallow surrounds with rustication to their doors.

wake – South Cliff from the early 1840s, the Esplanade there being completed by 1845. While these terraces make a similarly impressive statement in their scale and proportions, their fronts are finished with stucco rather than the ashlar of the Crescent houses. All seem to have been occupied as high-order lodging houses or by private individuals from well-to-do and influential families.

The Esplanade, Scarborough, early 1840s.

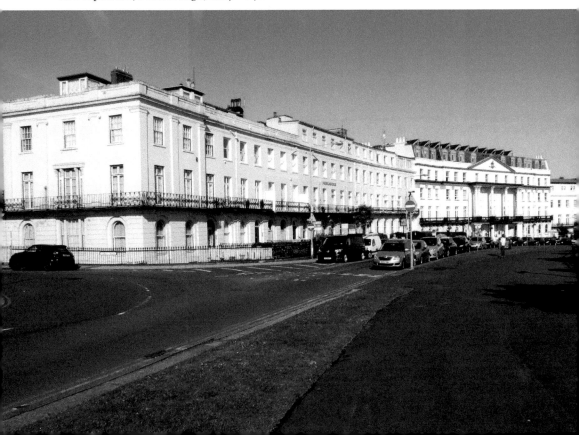

Other Crescents and Terraces

The crescent configuration of houses seems to have become a fashionable way of forming new streets and was employed at several resorts. At Whitby, George Hudson planned a grand crescent in the development of the West Cliff in the 1840s. Hudson's financial dealings, however, put a stop to the scheme, and by the 1850s Whitby's Royal Crescent was left half finished. Moreover, the half that had been completed lacked the skill in design demonstrated at Scarborough, for, while the detailing was competent enough, the fall of the site was not taken into account so that the run of windows go out of register in the middle, and then again just after the middle. At Filey John Wilkes Unett had plans drawn up for a crescent of houses and villas in 1835. The first plan was drawn up by the Birmingham architect Charles Edge showing a deep crescent with a hotel at its centre looking across the sea, together with public gardens front and rear. This was amended in 1838 to give a much shallower crescent with gardens to the front only. The houses here, however, do not provide a continuous crescent of building, but a series of short terraces arranged in a crescent.

Bridlington, too, had its crescent. Bridlington Quay's prominence as a resort had its heyday in the nineteenth century, and like other resorts, sufficient visitor accommodation was an issue. This was a state of affairs that the Bridlington Local Board attempted to remedy, and during 1868, it had offered for sale by auction

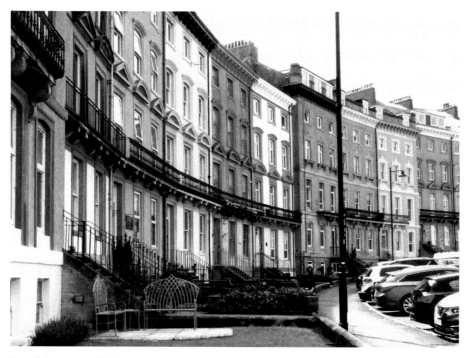

Royal Crescent, Whitby, 1850s.

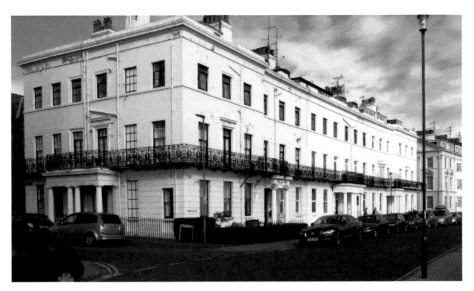

The first of the terraces on the Crescent, Filey, 1839–42 (either John Barry or Charles Edge).

building land north of the quay, close to the seafront. There were, however, no takers. Then in October of that year the board was approached by a builder who offered to buy the land 'providing the Board would deal liberally with him'. This was George W. Travis of Eccleshall Bierlow, near Sheffield. While Travis carried out the building of two streets here – the Crescent and Marlborough Terrace – the architect is more of a puzzle, but may have been Joseph Earnshaw. Whether Earnshaw was the designer or not, plans for the streets were approved in January 1869 by the Local Board, who believed that the houses to be 'erected in the form of a semi-crescent' would 'add greatly to the appearance of that which must soon become the most fashionable part of this already popular watering-place'.[12] The two streets seem to have been completed by the end of 1870 and were receiving their first guests in the summer of 1871.

Their design seems conventional enough: three-storeyed terraces with bay windows to the ground and first floors, together with attics and basements. Yet they seem stylistically mixed: Italianate keystones to some first- and ground-floor windows, but door heads and some first- and second-floor windows given mouldings that suggest Gothic – an unusual combination. Their arrangement is rather odd, too, for as the local press reported, the Crescent was really a semi-crescent. What draws the design together is the central garden shared with Marlborough Terrace. It consisted originally of an open central area with a fountain, the whole fenced round by an iron palisade. The Travis firm, often working with Earnshaw, was to build other streets and houses in Bridlington Quay, Cliff Street and Albion Street adjacent to the Crescent are two.

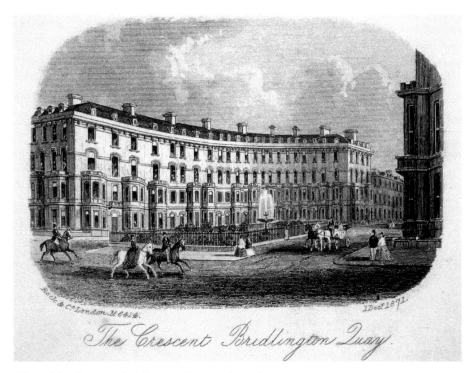

Rock & Co London N.6414.

1 Dec.t 1871.

The Crescent Bridlington Quay.

Above: The Crescent, Bridlington, from a view of 1871.

Below: The Crescent, Bridlington, today.

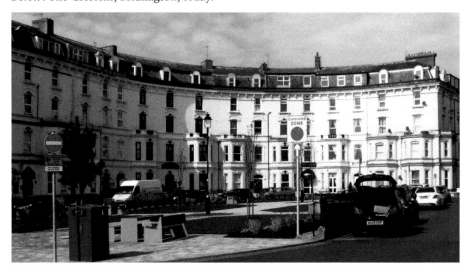

Time has not been kind to the Crescent and Marlborough Terrace. After neglect in the post-war years and later, restoration of some houses is now taking place. If what was a once 'fashionable part' of Bridlington is unlikely to reclaim such social cachet, the regeneration of this part of the town and its architecture is, nevertheless, a step in the right direction.

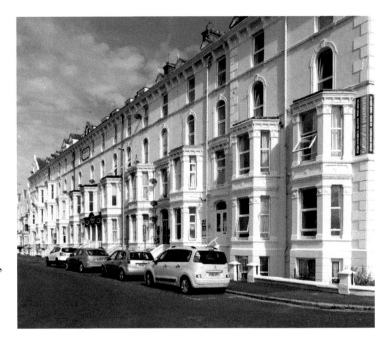

Albion Terrace,
Bridlington
(Joseph
Earnshaw,
1878).

Church Square, Whitby

Hudson's stalled plans for Whitby and his financial failure was not the end of the West Cliff suburb. His interests in Whitby, along with those of the North Eastern Railway, were bought out by the industrialist Sir George Elliot, and development of the West Cliff was to continue from the 1870s. The Whitby architect E. H. Smales worked with Elliot on his plans, and it is perhaps significant that Smales's elder brother, Charles, a timber merchant, and Robert Clifford, a joiner and builder, had also acquired interests in the area. By 1881, they had begun to erect a terrace of carefully detailed Gothic houses, possibly by E. H. Smales. The street became known as Church Square – Elliot had proposed a new church just opposite, donating the land and giving generously to the building fund. The first sod was cut in autumn 1883; building commenced in 1884; and the church of St Hilda was consecrated in 1888. The architect was Robert J. Johnson of Newcastle, who produced a dignified Decorated style of church with a tower, although the latter was not completed until 1938. What is often not acknowledged in this quiet area of Whitby, is its careful planning: St Hilda's looks east along Abbey Terrace, the view being stopped by St Mary's church and the site associated with St Hilda across the valley. As the *Whitby Gazette* commented in 1886: 'When the estate becomes extended and developed in accordance with plans already prepared, it will form a fitting centre to an immense pile of commodious dwelling houses.'

It would also answer: 'the grand old pile [St Mary's and the Abbey] which stands on the parallel eminence on the opposite cliff.' The area around Church

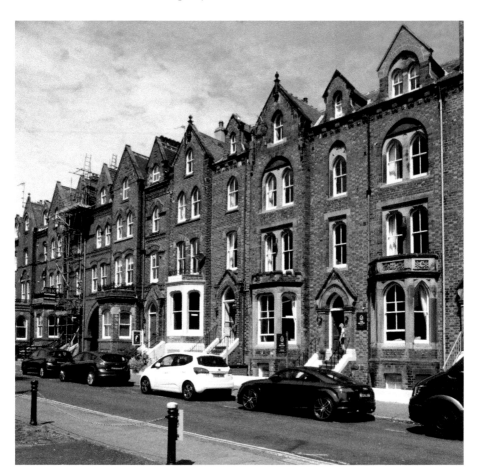

Church Square, Whitby (E. H. Smales attrib.).

Church Square, Whitby, with Gothic-panelled doors and the date '1881'. The initials 'RC' refer to Robert Clifford, its builder.

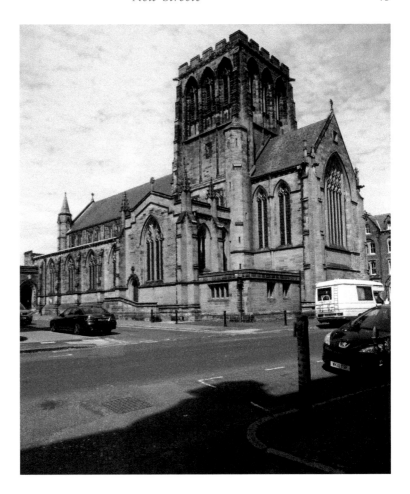

St Hilda's
Church,
Whitby.
(Robert
J. Johnson)

Square is a corner of Whitby little regarded, yet it shows an eye for design that the handling of the Royal Crescent lacks.

Grand terraces continued to be added to the county's resorts, and, if their designs were mostly classical or Italianate, others were Gothic. It is also worth adding that interior arrangements in terraces and crescents like these were similar to those of the villa, and in some cases, with a greater number of rooms. In other words, they were not the poor relation. This is obvious in the structure of many – towering bay windows, for instance, in stacks of three or four. Also, their plans might accommodate service areas in the basement, a kitchen, a housekeeper's room and possibly a servants' hall. The major difference was in the location of the drawing room which, unlike the villa, was usually on the first floor, whether this was a lodging house or private residence. The adoption of this metropolitan town-house plan may seem strange at first sight, but it reflects the sort of people for whom such houses were built. Whether for permanent residents or sojourners it indicates the conservative and well-heeled lifestyle their occupants expected.

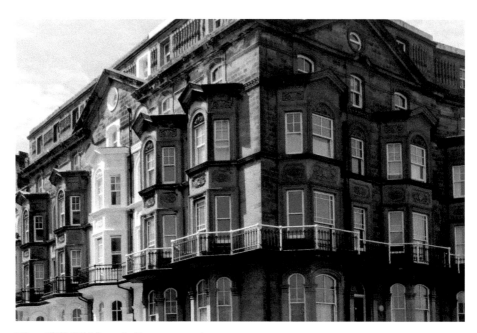

West Cliff, Whitby – Italianate terracing.

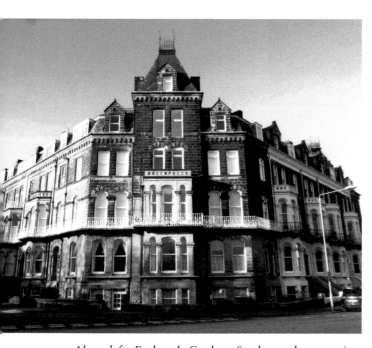

Above left: Esplanade Gardens, Scarborough – terracing with Gothic emphasis.

Above right: Bay windows, Prince of Wales Terrace, Scarborough.

Right: Entrance below steps to a service basement, Scarborough.

Below: The Crescent, Filey. Plots behind the terraces might be used to locate carriage houses and stables, here converted to other uses.

5

The Luxury Hotel

Not everyone wished to build or buy a house by the sea. A summer stay on the coast might have been part of the social year for many well-to-do families but for some, good quality accommodation at an inn, lodging house or hotel was preferable to the responsibility of a second home. At lodging houses, a family might take over a house for the season, or several guests might be accommodated, and both meet and dine in common. A picture of lodging house life is painted by William Hutton of Birmingham while staying at Coatham with his daughter Catherine in 1808 and 1809. At their lodgings the 'company' consisted of an upper middle section of society – elderly women of independent means, a banker, a lawyer and someone 'having a fortune left him of fifty thousand pounds.'[13] They

Below left: Haggersgate, Whitby, contained high-quality lodging houses.

Below right: Many lodging houses in Merchants' Row, Scarborough, were demolished for street widening. This pair of houses survives to speak of its former character.

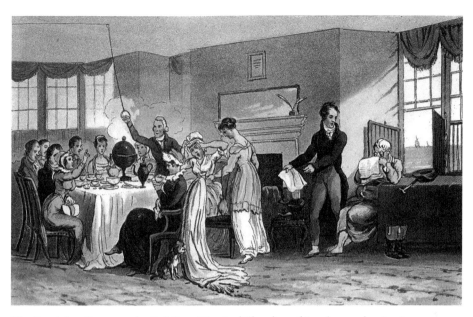

The Breakfast Room at the Bell Inn. (*Poetical Sketches of Scarborough,* 1813)

dined together, met and conversed together and enjoyed entertainment together. By the 1840s, while such customs continued, new demands arose as elite families began to expect a higher standard of service and a greater regard to privacy. These demands were met by the rise of a new class of hotel, a luxury hotel.

The seaside hotel was somewhat different from hotels at inland towns, an obvious difference being its location and facilities. One of the principal reasons for visiting coastal resorts was health, and while drinking sea water or spa water may have declined during the nineteenth century, sea bathing and the medicinal qualities of brine baths did not. The more successful of these seaside hotels were to capitalise on this. Perhaps the first such hotel to be purpose-built on the Yorkshire coast was the Marine Hotel, 1837, to the north of Hornsea, the speculation of Daniel Jameson.[14] Initially, this was probably more like a substantial inn, both in scale and accommodation, but in 1842 Jameson sold it to a wine and spirits merchant from Hull, Thomas Cunnington, who appears to have extended it into something grander. It contained seventy rooms (by the 1860s, 100 rooms), which was large at the time, and it offered warm baths, shower baths and the use of carriages for 'invalids'. That it attracted well-to-do guests is suggested by a retrospective piece in the *Hull Daily Mail* of 27 May 1897, which stated, 'In those days the Duke of St Albans and other exalted personages [stayed there].' It was situated close to the sea – appealing, but risky on this coastline. In 1867 piles were driven into the front cliff to stabilise the hotel, but in December of the same year it caught fire and was extensively damaged.

Others followed. By the mid-1840s the Crown Hotel had been built at Scarborough, part of the South Cliff development of the town, and was leased

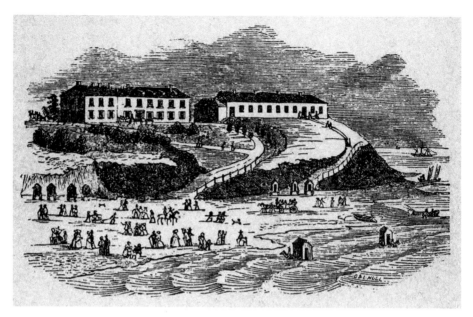

The Marine Hotel, Hornsea. This hotel has not survived, but early engravings indicate a building of two phases and possibly a refreshment room extension.

by a young hotelier from Ripon, John F. Sharpin. His aim seems to have been to attract 'the quality' to the Crown and throughout the 1840s he advertised its benefits in both the provincial and London newspapers:

> Families who are about to visit this 'Queen of the British Watering Places', will find the above-named extensive establishment most delightfully situated commanding a full view of the sea. Hot, Cold, and Shower Baths in the house, combined with every convenience and comfort ... Good stabling, post horses, and airing carriages kept. An omnibus and cabs await the arrival of trains.[15]

When Edward Baker, a wholesale druggist from London, stayed there in 1850, he noted in his diary: 'some very aristocratic people here.'[16] This was not the only superior hotel in Scarborough and it had rivals in Donner's near St Nicholas Cliff or the Queen's Hotel on the North Cliff, which also attracted some distinguished visitors – a good part of the French royal family in 1856, for example.[17]

What some of these early hotels had in common is that they were opened in the days either before railways had been built or before there was a rail network. Travel to resorts was by horse, stagecoach or private carriage, and hotels built by the sea thus required extensive stabling in the season. Its extent at Scarborough's Crown, for instance, is recorded on the 60-inch sheet of the Ordnance Survey map published in 1852 which depicts a huge area of stables to the rear of the hotel. The railways changed travel radically. While the need for horse-drawn transport remained, it was mostly a local need and a reduction in stabling followed at hotels built after about 1850.

Above: The Crown Hotel, Scarborough
(John Gibson, 1840s).

Right: Remains of what was a vast area
of stabling behind the Crown Hotel. It
has been converted to many different uses
over the years.

Throughout the 1850s and 1860s numbers of hotels were built at Yorkshire
resorts either by the railway companies or by private enterprise. The first railway
hotel at a Yorkshire resort was the Queen's Hotel, Withernsea, designed by
Cuthbert Brodrick in 1853 for the Hull & Holderness Railway, although the
1849 Royal Hotel at Whitby was, arguably, the earlier. The latter was designed
by John Dobson of Newcastle for George Hudson of the York & North Midland
Railway, but whether it could be regarded as a railway hotel or part of Hudson's
development of the West Cliff is open to question.

Above: The Queen's Hotel, Withernsea (Cuthbert Brodrick, 1853; demolished).

Below left: The Royal Hotel, Whitby, features Dobson's sleek and almost featureless classical design. There was originally a balcony running at first-floor level.

Below right: The Crescent Hotel, Filey – part of the New Filey development (John Petch, 1853).

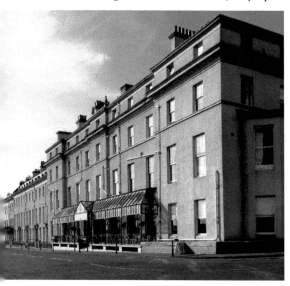

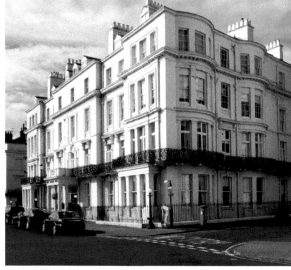

The 1860s, however, saw the appearance of the luxury hotel, which was different in scale, style and quality. The Zetland Hotel at Saltburn was a venture that Henry Pease seems to have persuaded his fellow directors of the Stockton & Darlington Railway to undertake. Opened in 1863 and designed in a French-influenced style by the company's architect William Peachey, it stood at the head

of the rail terminus, three storeys high, with 120 rooms and direct access from the station. Further hotels on this scale were to follow, some designed in full-blooded French Second Empire styles. In 1863, W. B. Stewart designed the Alexandra Hotel for the Bridlington Quay Hotel Company. Located to the north of the quay at Sewerby Terrace, it was possibly the first hotel of fireproof construction in the region.

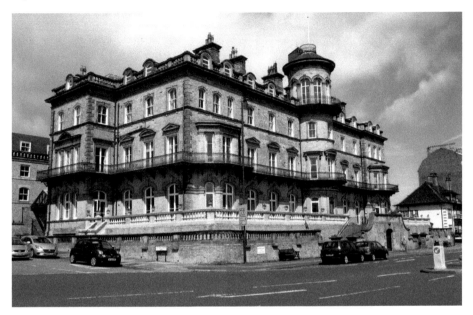

Above: The Zetland Hotel, Saltburn (William Peachey, 1863).

Right: The Alexandra Hotel, Bridlington, from an engraving of 1868. Its frontage conveys an imposing French air (W. B. Stewart, 1863; demolished).

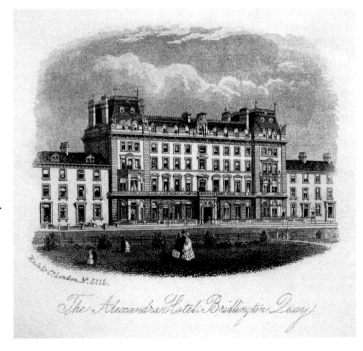

The Grand Hotel, Scarborough

A contemporary of both the above was the Grand Hotel, Scarborough, a prospectus for its construction being published in 1862 by the Cliff Hotel Company. Squabbling among the board of directors, however, and the failure of the original building contractor, led to the hotel's completion being delayed until 1867. Its architect was Cuthbert Brodrick, who created what is arguably the most accomplished Second Empire design of hotel in Britain, yet it has been continually misinterpreted. To begin with, the architectural press did not approve. The *Building News* commented that Brodrick's drawing of the hotel, which was exhibited at the Royal Academy's exhibition in 1867, displayed four domes that looked like 'roe's eggs', and that the 'rest of the building is of ordinary hotel character'; *The Architect* considered it 'architecturally speaking, a failure'.[18] Local myths have also arisen that are similarly wide of the mark, portraying Brodrick as creating an allegory of time and patriotism: four domes (the seasons), twelve storeys, 365 rooms; V-shaped in honour of Queen Victoria; the largest hotel in Europe. Both contemporary critics and local historians have misconstrued Brodrick's design. Newspaper reports of the opening agree that there were around 350 rooms.[19] At this capacity it was then the largest hotel in England, but the largest in Europe was probably the Grand Hotel, Paris, 1861–62, with 800 rooms.

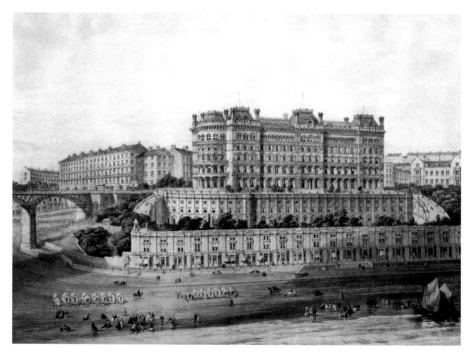

Brodrick's first design for Scarborough's Grand (originally the Cliff) Hotel of *c.* 1862. The row of houses and shops along the seafront were never built and the original design was modified.

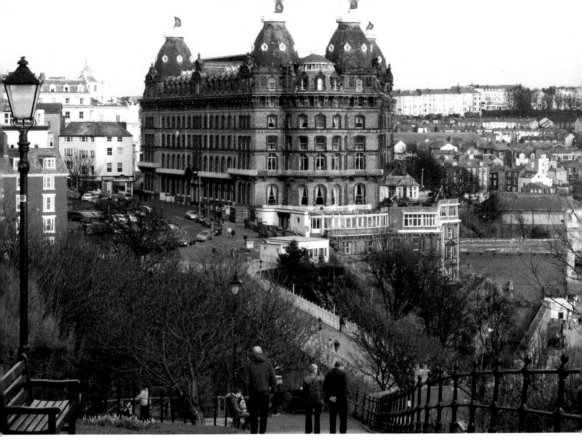

The Grand Hotel as finally built.

Yet the Scarborough Grand *is* an extraordinary building and Paris is the key to its design. While some contemporary critics seem convinced that the Grand was designed in an Italianate style, classical French architecture, and in particular the reconstruction of Paris by Napoleon III seems the fundamental influence. What Brodrick produced was an imposing Parisian block with corner towers and domes relocated to the north-east coast of England. In the treatment of the roofline in particular, the greatest homage to France is paid. Four domes mark the ends of the two ranges. The corner towers are sumptuously finished above the eaves with sculptural embellishment incorporating marine creatures and foliage together with classical masks. Atlantes (male figures) dressed in lion skins support pediments, while flanking the south-west and south-east of the apex we find caryatids (female figures). The caryatids here are in the form of the seasons, perhaps reflecting the directors' claim that Scarborough offered a pleasant residence all year round, for 'the season at Scarborough has been for some years extending into the autumn and winter months'.[20] The Grand's sculpture seems to have been executed by the Leeds firm of sculptors Burstall and Taylor.

There was more to the hotel than its uncompromising appearance. The interior was fitted with the latest technology: service hoists, an 'ascending room' (lift for guests), electric bells from guests' rooms to reception, speaking tubes connecting each floor with reception or the manager's office, a telegraph, and so on. The drawing

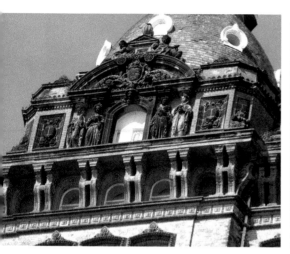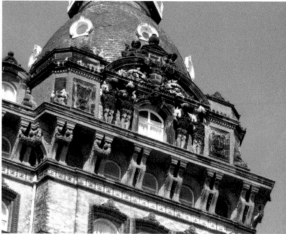

Above left: The sculptural embellishment above the eaves is spectacular. Here, four female figures (caryatids) in the form of the seasons support a richly decorated pediment above one of the windows.

Above right: While here and along the sides male figures dressed in lion skins (Atlantes) are employed.

room, with views across the bay, was lit by four gas standards in the form of bronze statues rising from ottomans. In the provision of food also the Grand would appear to have scored well above its rivals. Its boast was that the dining room could accommodate 500, and its kitchens had been equipped with some fastidiousness. From its opening the Grand was presided over by Augustus Fricour, former manager of the Hotel Mirabeau, Paris, who had also been consulted on the fitting of these kitchens. Here was a further factor that set such hotels apart: improved standards of food and a rising interest in cuisine. Yet this did not please everyone. While staying at the Grand Hotel, Scarborough, around 1890, the poet and travel writer Percy Tunnicliff Cowley seems to have been discomposed by the Continental air of the Grand. The waiters were either 'German, French, or Danish', and the food French:

> sat down to dinner á la *Francaise*, and enjoyed it. I say *enjoyed*; but I am bound to admit I very strongly object to a French *cuisine* … When you have *entrees* dished up with sauce this and sauce that á la *Francaise*, I defy any ordinary Englishman to come up with an accurate idea of what he is eating … Why cannot we have our English food served up in the good old English fashion?[21]

The Grand Hotel should be recognised for what it represented. It was among a group of internationally important hotels that emerged in the 1850s and 1860s in capital cities and fashionable watering places, and whether this were London or Paris, Brighton, Baden or Lucerne, such hotels courted and catered for the demands of a wealthy international elite.

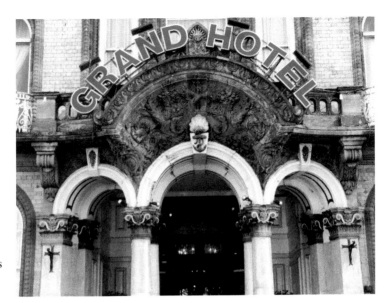

The entrance, a swirling marine fantasy in which the anchor perhaps symbolises 'at rest'.

Later Years

During the 1870s and 1880s the pace of hotel building seems to have slackened, and nothing was built to compare with the grand hotels brought into being in the 1860s. This may have had its origins in recession in the textile and iron industries in the 1870s; some areas of agricultural production also declined. Perhaps this was the reason, for instance, why one of the few grand hotels to be built in this decade – the Coatham Hotel at Coatham – was seemingly never completed, its east wing remaining unfinished at its opening in 1872, although the proprietor was still advertising an image of its originally intended form as late as 1877.

The building of grand hotels did not resume until the 1890s, yet even then some schemes failed to come to fruition, such as the development of the south of Bridlington Quay. This included a hotel, but it did not materialise, and the site was sold to the Leeds contractors, Whitaker Brothers. That firm, however, was to play a significant role in the building of two other hotels. The first is an odd one in that the hotel planned for the new resort of Ravenscar survives to this day, but the resort itself failed. Plans were in train by 1896 to convert the older Peak or Raven Hall into a hotel. The architect Frank Tugwell did this by linking a large new hotel building to Raven Hall on its north side, in a classical design which was probably thought to harmonise with the older building. The new hotel was advertised as being open at the end of December in 1896 and 'furnished throughout like a comfortable country house'.[22] Whitakers seem to have been the contractors for both this and the Hotel Metropole in nearby Whitby. The latter was described as 'recently erected' by them in a public offering of shares advertised widely in the press in July 1898. Several of the directors – Walter R. S. Pyman or James Sharphouse Moss – were local shipowners and it seems likely that a syndicate

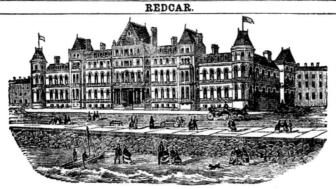

REDCAR.

THE COATHAM HOTEL,
COATHAM, REDCAR, YORKSHIRE.

THIS New First-class Hotel is within three minutes' walk of the Railway Station and beautifully situated on the shores of the German Ocean. The Victoria Pier 250 feet in length, stretches into the sea in front, and affords an unrivalled promenade. The sands are unequalled on the coasts of Great Britain. Tariff on application to

Sh.-281]

Mr. ELLIS JONES, Manager.

The Coatham Hotel, Coatham, from Bradshaw's *Railway Guide*, 1877 (Charles John Adam). It was proposed to add the wings after the central body was completed...

...but the eastern part (left) was never added. (© Mick Garratt, cc-by-sa/2.0)

of northern businessmen and Whitaker Brothers were responsible. The architects were Chorley and Connon of Leeds who produced a design difficult to categorise. Its form is a block four storeys high, but with corner towers rising to five storeys and ending in pyramid roofs. In the centres of the north and east faces there are shallow towers ending in curvilinear gables. Whether one likes this architectural style or not, the Whitby Metropole makes a spectacular contribution to the West Cliff. When it opened in summer, 1898, it offered 'Suites with Private Bath-rooms, 100 Bed-rooms. Electric Light, Passenger Lift'.[23] It probably also brought Whitby more to the attention of the well-heeled as a holiday destination, with one advertisement even comparing the place to the Swiss mountains – 'Fashionable Whitby. The Engadine of England'.[24] Certainly the Metropole attracted some fashionable and notable visitors. As visitor lists at the end of the century show, guests came from across Britain as well as from other parts of the world, such as Europe and America. They comprised numbers of aristocracy plus elite commercial and industrial families, its most honoured guest being probably HRH the Maharajah of Cooch Behar and his servants.

These were the last of the luxury hotels to be built on the Yorkshire coast, and, along with some smaller but select ones, they continued to function as such until the beginning of the twentieth century and later. By then several had been absorbed into hotel groups. The Hudson Hotels Company, for example, owned the Crescent at Filey, the Crown at Scarborough and Raven Hall; Hotel Metropole at Whitby became part of the Frederick Hotels Company, Frederick Gordon being one of the outstanding hotel entrepreneurs of the nineteenth century owning luxury

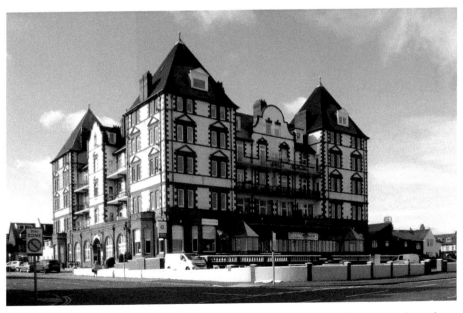

Hotel Metropole, Whitby (Chorley and Connon, *c.* 1898). The design may have been influenced by Alfred Waterhouse's Hotel Metropole, Brighton.

hotels in both England and Europe. Lodging houses and small hotels continued to be built throughout the nineteenth century, supplying accommodation to the many thousands of visitors to the county's coastal resorts, but they operated on a different level, and offered little competition. This was in part a result of scale, in part standards of service. Setting was a further decisive factor. The Grand at Scarborough, the Alexandra at Bridlington Quay, the Zetland at Saltburn and the Metropole at Whitby could all provide meticulous service in superior locations. All signalled this difference by their architectural presence, many on clifftop sites and taking advantage of the best views. In this sense they also implied a social hierarchy in which their guests occupied the topmost tier.

6

Taking the Waters

Health tourism in Britain generally was increasing during the later seventeenth and eighteenth centuries. The discovery of mineral springs in several places attracted genteel tourists in search of health cures, and coastal resorts had the added allure of the sea, which in itself was thought to hold therapeutic benefits. The Yorkshire coast proved no exception. From the late seventeenth century several sources comment on Scarborough and its mineral spring, which was analysed and much commended. This spring was at the foot of a cliff near the beach. It is clear that by 1700 the sea itself had become an attraction, as depicted in the artist John Settrington's view of 1735 showing bathing machines on the beach: Scarborough was possibly the first seaside health resort in England. Much the same could be said of Whitby, as noted in Chapter 1. Over the course of the eighteenth century several places in Yorkshire came to be valued for bathing, and by the mid-nineteenth century, all of the resorts discussed in Chapter 1 could be

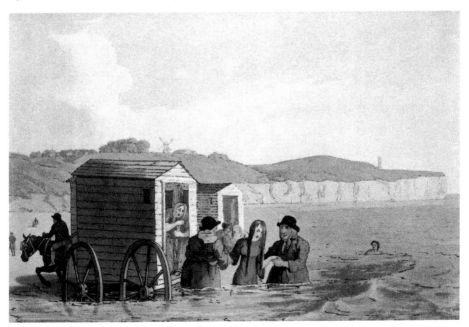

Sea bathing at Bridlington, from George Walker's *The Costume of Yorkshire*, 1814.

included. A distinction should be made between swimming and bathing. While there may have been a 'folk tradition' of swimming in the sea, what society of the eighteenth and nineteenth centuries came to indulge in was bathing, also known as dipping – having stepped into the sea, attendants known as 'dippers' would submerge you for a time and help you back out.

Cold bathing in the sea came to be recognised and recommended as a remedy for many ailments, and numbers of treatises were published on the subject. These works illustrate the early and continuing attention that the medical profession gave to the therapeutic effects of the sea. To take full advantage, the human body, so some believed, had to be immersed naked in the waters. This was not to everyone's liking, nor did everyone possess a robust enough constitution to plunge into cold seawater. This provided the medical profession with the opportunity of

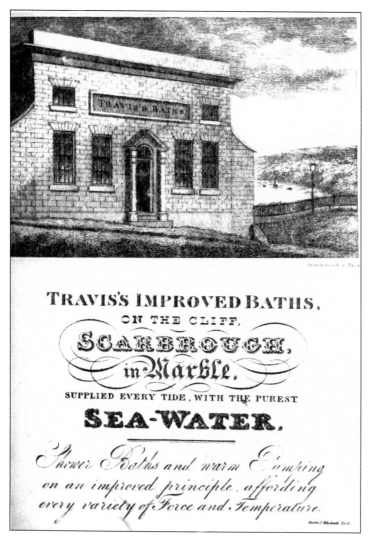

Travis's Baths from an advertisement.

offering a further means of consuming the sea in the form of indoor baths, but baths filled with water pumped from the sea. Indoor baths had been constructed at Margate by 1736, which were probably the earliest in the country.[25] Other resorts did not apparently acquire this means of bathing until later in the eighteenth or nineteenth century. It occurred at Scarborough around 1798, when Travis's Baths were in operation on the cliff. William Travis was a Scarborough physician, and the baths operated until the mid-nineteenth century, by which time they had been extended and rebuilt. They were described as a:

> respectable establishment, situated at the entrance to St. Nicholas' Cliff ... originally opened in 1798. It has since been re-built, and the interior fitted up with every attention to comfort and elegance. The Baths are of wood and marble, and are adapted either for plunging, sitting, or the recumbent position. Every tide, these baths are supplied with pure sea water, and admit of every variety of temperature. Rooms are also fitted up for Steam, the Douche, and Shower Baths.[26]

Further baths followed, such as at Bridlington Quay around 1801 and Whitby around 1826.

Sea bathing continued in the nineteenth century, but was to be rivalled by a growing enthusiasm for swimming. During the first half of the century specially designed covered swimming baths started to appear. Probably the first on Yorkshire's coast was opened in Scarborough in 1859. The Scarborough Public Baths could accommodate up to fifty swimmers in a central pool but with individual baths for treatments of various kinds located around the pool. A late

An unfortunate incident at Travis's Baths! (*Poetical Sketches of Scarborough*, 1813)

Falsgrave Hydro (J. Caleb Petch, 1889).

Its founder was R. B. D. Wells, a leading practitioner of phrenology.

example of the swimming bath combined with hydropathic therapies was the building that was known as the Brine Baths at Saltburn, which opened in 1891. Sadly, the architecture of both baths and swimming baths at Yorkshire's coastal resorts has not survived.

One further development in coastal health tourism was the building of hydropathic hotels. Most took shape in the 1880s and 1890s, when, with the exception of places like Harrogate, the fashion for hydros was beginning to fade. Those built seem to have catered for the middling and upper ranks of the middle class rather than an elite. Among the few former hydros to have survived is the Hydropathic Establishment at Falsgrave, Scarborough. Built to the designs of J. C. Petch in 1889, it offered holistic medical treatment: the water cure, homeopathy and phrenology, and proved popular enough to merit extension in 1891. Further hydros were to follow, such as The Hydro at Bridlington Quay in 1898. Perhaps the last, and certainly the most unfortunate, of these establishments was the Imperial Hydro Hotel at Hornsea, which offered, besides the usual treatments, both Turkish and Russian baths. Launched in 1913, it had a short life as a hydro, being requisitioned by the War Office in 1915 followed by an auction of its contents in 1920.

Health was not the only pursuit. For those of a less-clinical nature, other activities were available. These are explored in the next section.

The hydro was so successful that a new company was formed, adding an extension to its garden front in 1891 (J. Caleb Petch). Wells became managing director.

Hydropathic Establishment in terracotta.

7

Building for Leisure

The principal reason given for visiting seaside resorts was said to have been health. Nevertheless, the early development of resort towns on the coast should not be seen as separate from the eighteenth-century development of inland resorts and spas. There, privileged members of society met not simply for the waters, but to enjoy a range of leisure activities from theatre-going or dancing to racing or cards or the pleasures of social intercourse generally. As the gentleman naturalist and traveller Thomas Pennant more cynically put it in 1769, 'health is the pretence, but dissipation the end'.[27] Throughout the nineteenth century the number of leisure activities at resorts grew. Scarborough, as the first resort, excelled the rest; Bridlington Quay and Whitby were to develop and promote such activities largely in the nineteenth century, as did others. What follows details this growth in leisure and its buildings.

The Spa and the Public Rooms

Drinking the waters usually necessitated a spa building. The term 'spa', however, should not be confused with simply spring waters, for spa buildings grew to contain more than a place to imbibe: by the mid-nineteenth century and later they might include concert halls, reading rooms, lecture theatres and possibly spaces for promenading and socialising. Only at Scarborough and Filey do spa buildings from the nineteenth century survive, if altered in later years.

Scarborough's spa was the largest on the Yorkshire coast, and what we see today is the result of its being reconstructed three times during the nineteenth century with additions in the twentieth. Surprisingly, and despite its being frequented by numbers of aristocratic families, it was never architecturally elaborate and was approached by a steep descent from the cliffs above. Matters changed when the Cliff Bridge was opened in 1827, spanning the valley between St Nicholas and South Cliffs and providing a gentle incline to the spa. The spa itself consisted of two wells by this time rather than the original spring: the chalybeate (containing salts of iron) and saline wells. After storm damage in 1836, the spa was rebuilt between 1837 and 1839 to a castellated Gothic design by Henry Wyatt, the first time it had been given an architectural presence. At the same time, the cliffs around

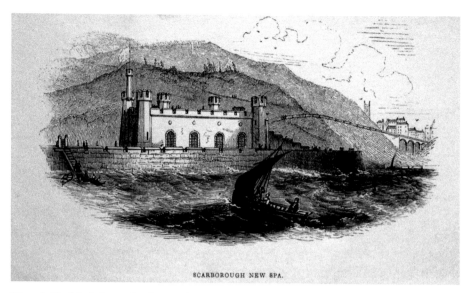

Wyatt's Gothic Saloon, Scarborough, 1839.

the new spa were laid out with walks, arbours and seats. Extensions took place in 1857–58 by Paxton and Stokes who added further to the landscape; a bandstand and prospect tower were also included. Disaster struck in 1876 in a great fire. Yet Scarborough's spa was such an icon of upper-class entertainment and recreation

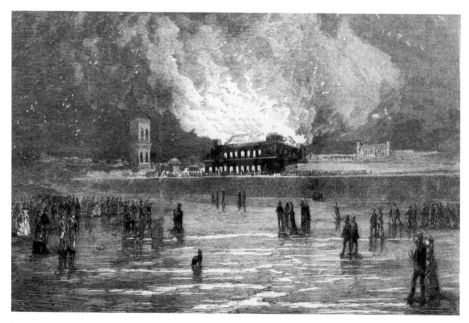

The Paxton and Stokes building was gutted by fire in 1876. (*Illustrated London News*, 16 September 1876)

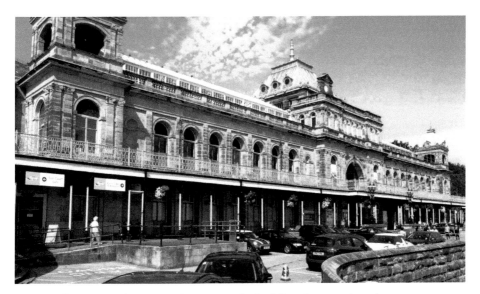

Verity and Hunt's replacement of 1877–80, the building that stands today.

that a rebuilding began in 1877, the architects Verity and Hunt being the winners of a competition for the design. This encompassed further extension, including a grand hall besides other spaces for leisure. The importance attached to the spa can also be judged by the interior decorators chosen who were leading practitioners of their day. The Paxton and Stokes building had been decorated by the Crace family; the Verity and Hunt building by Fredrick Arthur. Both were eminent firms and interior decorators to Queen Victoria.

The Spa was leased by the Scarborough Cliff Bridge Company. This is given recognition by a relief of the bridge above the main entrance.

Just to the north, steps led down to the Spa Wells. Although they enjoyed a revival in the 1920s, they were eliminated after the spa was returned to council control in 1958. Their site was approximately the raised area with a Pay and Display machine.

Filey also had a spa, first mentioned in the 1730s. It was situated on Carr Naze high above a cliff washed by the sea. By 1850 a tiny spa building had been erected there for ease of public access, although hardly satisfactory, and as visitor numbers grew with the extension of 'New Filey', such facilities proved inadequate. In 1861, the Filey Public Bath and Saloon Company published its prospectus for what was described as a 'further attraction'.[28] It is clear the company wanted to take advantage of the market in health, and it planned an ambitious undertaking comprising hot, cold, shower and vapour baths; a reading room and saloon; and a spacious hall. Water to the baths seems to have been pumped from the sea. Over the years this provided therapeutic bathing in privacy, as well as space for public meetings and other events. The Baths Saloon, or more commonly the Spa Saloon, was designed by William Baldwin Stewart, who produced a design influenced by French classicism, employing sweeping Mansard roofs with scallop pattern roof tiles and *oeil-de-boeuf* windows providing a touch of French chic, as did the elongated first-floor windows and balcony before being altered later. Yet there is something else that is different about this building. Although born in London, Stewart spent his early twenties in practice on Broadway, New York, where he may well have been influenced by American expressions of the style. Whatever the origins, the architectural importance of the Spa Saloon lies in the early appearance of French classicism at a Yorkshire coastal resort.

Spas had become entertainment complexes. In this sense they replaced earlier assembly rooms and were comparable with other contemporary buildings sometimes referred to as public rooms, where similar provision was on offer.

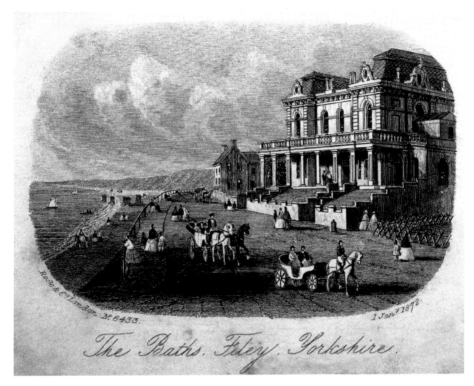

The Baths, Filey, Yorkshire.

Above: Filey's Spa Saloon was designed by William Baldwin Stewart, who had worked in America before returning to England, settling in Scarborough shortly after 1858.

Right: The Spa Saloon today. The windows on the first floor have been altered. It has recently been converted to apartments.

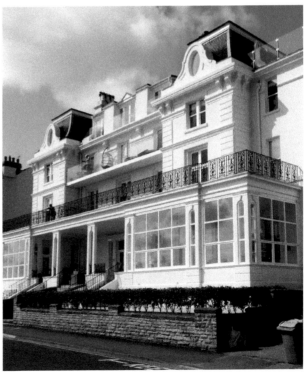

Scarborough, however, could also boast its new Assembly Rooms (1857) in Huntriss Row where Dickens twice gave readings. At Bridlington Quay, in response to complaints that it lacked places of entertainment, the Victoria Promenade and Polytechnic Rooms were opened in 1848. A castellated Gothic building fronting the Quay, it was designed by Sheffield architect Samuel Worth and contained concert, reading and refreshment rooms (demolished). At Whitby the Angel Hotel – the premier accommodation in the town until the 1840s – had an assembly room by at least 1773, which was replaced in 1855 by St Hilda's Hall, supplying public rooms with an orchestral chamber. It was said to have had a seating capacity of 800 and been designed by Atkinson of York for the proprietors of the Angel.[29] At other places, schemes were cut short or never materialised. Ambitions at Saltburn, for instance, were thwarted by a severe depression in the iron industry. Plans proposed for Assembly Rooms with a library, reading and refreshment rooms were never built, although the design by John Ross of Darlington was illustrated in the *Builder* on 22 October 1864.

St Hilda's
Hall, Whitby
(1855; J. B. &
W. Atkinson
attrib).

The Scarborough Aquarium

To cater for the cultivated tastes of visitors, cultural activities were offered: museums, music, public lectures, for example. Scarborough led the way. From early in the eighteenth century the town had possessed a theatre. By the early years of the nineteenth, learned societies were being formed – principally the Scarborough Philosophical Society – and, since Scarborough had become a focus of geological enquiry, the Rotunda Museum of 1829, was one outcome, housing geological and archaeological collections. Other structures devoted to rational or scientific interests were to follow. In the 1870s, however, came the most remarkable of Scarborough's museums, the Marine Aquarium. Public aquariums were largely an innovation of the nineteenth century. They should be regarded in the wider narrative of the museum movement which brought a moral and political purpose to the establishment of such institutions. They were not simply to become places where collections were stored or displayed but places of 'rational amusement of an elevating character'. The Aquarium at Brighton, for example, was 'intended to *instruct* as well as to delight, and at once to excite and gratify a thirst for

The Rotunda
Museum, Scarborough
(R. H. Sharp, 1829;
wings added 1861).

information'. The aquarium proposed for Scarborough was discussed in similar terms – as alderman Woodall of Scarborough put it, the aquarium should be 'an educational establishment, and not a mere gazebo or vulgar show'.[30]

Its beginnings were in 1871 when the Scarborough Sub-Tramway, Aquarium, and Improvement Company Limited proposed to construct a public aquarium on a 9-acre site in the North Bay, but this seems to have come to nothing. A further company was formed in 1873 and placed plans before Scarborough Council for permission to construct the aquarium on land leased from the council. The Marine Aquarium Company Scarborough Limited was to lay out a vast subterranean space below the Cliff Bridge and adjacent to the sands in the South Bay. According to successive reports in the *Scarborough Gazette* in 1873, the earliest plans submitted were by Eugenius Birch, a railway and marine engineer of outstanding expertise. He had been responsible in 1870–71 for the Brighton Aquarium, an undertaking on a similar scale. At Scarborough, Birch worked with the architects and contractors Kirk and Parry of Sleaford, who appear to have undertaken the construction work and supervised a design that seems to have been solely Birch's. The work took place between approximately 1875 and 1877, beginning with a massive excavation over a 3-acre site.[31] This provided 125,000 square feet of accommodation, according to the *Scarborough Gazette*, compared with 72,500 at Brighton. Its tanks contained many types of fish, both fresh and saltwater, together with crustaceans, octopuses and turtles; other tanks were devoted to marine plants; others again to diving birds, seals and alligators. There was also a stage, set in a 'romantic rockery', where concerts of light classical and vocal music were performed, together with both a reading room and a dining room. It had cost above £100,000 to build.

Most remarkable of all was its interior. The plan provided for two long walls of tanks with corridors running to a central hall, the whole designed in an Indian-derived style and covered by a vaulted and top-lit roof supported by a series of elaborately decorated horseshoe arches. The provincial press went into some surprisingly detailed accounts of the design sources in their May editions, mentioning specific Indian monuments, although now difficult to verify. One source, however, appears to have been the Red Fort at Delhi and in particular the room known as the Diwan-i-Khas whose arcaded interior may have been the model. But whatever sources Birch used, his design celebrates Britain's progress in engineering and science, expressing this through a majestic reinterpretation of Imperial Mughal architecture.

The Aquarium at Scarborough met with faltering success, and the 1880s proved a troubled time. It was offered for sale in 1886, to be bought by a syndicate of businessmen headed by William Morgan of the Winter Gardens, Blackpool. It went for a miserable £4,500. During the course of the next year the Aquarium underwent a transformation, being renamed The People's Palace and Aquarium. As the *Scarborough Gazette* put it in May 1887, 'A tank full of haddocks ... will be no other a year hence,' but a 'series of sparkling entertainments' were worth returning for – its educative nature was lost in the new company's philosophy.

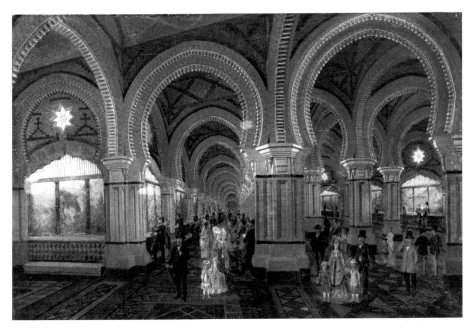

Above: Scarborough Marine Aquarium from a nineteenth-century painting. (Scarborough Museums Trust)

Below: The Diwan-i-Khas, Delhi. (*The Illustrated London News*)

The site of the aquarium today.

By 1900 the clouds were again gathering, and between that date and 1920 it went through a number of hands to be sold in 1923 to Scarborough Council, re-emerging as Gala Land, a 'fun city'. It survived into the 1960s before being demolished in 1968. The destruction of the Scarborough Aquarium was perhaps the greatest loss of Victorian architecture and engineering on the Yorkshire coast.

Sport

One activity has left behind hardly any architectural remains and yet was an important part of a stay on the coast for many – sport. In this respect the importance of horse racing cannot be overestimated. Horse racing was well established in the county, and race meetings could also be expected at some resorts. In 1764, for example, the novelist Laurence Sterne wrote to a friend that he had just, 'returned from Scarborough, where I have been drinking the waters ever since the races'.[32] At most resorts, however, meetings were not held regularly and did not take place on specially constructed courses but on the sands. While touring the Yorkshire coast in 1801, Dorothy Richardson of North Bierley Hall, near

Bradford, attended racing at Scarborough on the sands below the spa rather than the racecourse on nearby Seamer Moor. It was viewed from a railed area above 'filled with company to see the race, Ladies, Gentlemen, Sailors & the mob men, women & children all crowded together without any distinction of persons'.[33] Later in the century, however, recreations came under increasing regulation. Races that had traditionally taken place on the sands were removed to inland courses with grandstands and were usually under Jockey Club rules – both Scarborough and Redcar, for example, had new courses laid out.

These developments can be viewed as constraints that instilled better order and propriety, and they crept into other sporting activities. One particularly associated with the sea was yachting. If yachting was a rich man's pastime, it was to become more socially inclusive by means of the regatta. Regattas were held at some Yorkshire resorts from early dates. The Whitby regatta, for instance, was being held by the 1840s. In 1848, it was under the patronage of the Earl of Mulgrave and attended by local gentry and Members of Parliament. This regatta demonstrates how the sport could be restructured, becoming more socially open. It began with yachting and concluded with coble races, thus allowing fishermen and other manual workers to participate, but in a controlled contest.

Other sporting activities and events were those that promoted wholesome exercise, prowess and gamesmanship. Several, however, seem aimed at excluding working and lower middle-class players (golf), yet might encourage respectable female participation (tennis, croquet; golf later in the century). Others might be reformed under elite patronage to promote moral improvement or inter-class participation either by spectators or players. Cricket is a good example. Several resorts had cricket teams – Bridlington, Filey, Hornsea, Redcar – but one of the earlier was Scarborough's, which was founded in 1849. Its promotion and reputation were to gain under the patronage of Lord Londesborough and Sir Harcourt Johnstone, leading to a nationally important cricket festival from around 1875. In many of these sports, those lower down the social scale were encouraged to participate, although a sense of social hierarchy was, nevertheless, present, and was lampooned by the novelist Osbert Sitwell: 'the necessary appearance of democratic independence and good fellowship (jolly-good-sportsmanship-and-all-that-and-not-a-bit-stuck-up-either).'[34]

Social Pleasures

For probably the greater part of elite society, the chief recreation was the social intercourse that might take place at a variety of venues, some of which have been outlined above. Probably the best contemporary summary of how the day might be passed at a select resort occurs in, of all journals, *The Builder* – devoted to architecture, engineering, design and surveying, yet containing from time to time

accounts of cities, towns and resorts. Here is how the fashionable might spend
their day at Scarborough in 1861:

> The early part of the morning is spent on the sands, either in bathing, or looking
> at those who do so. From eleven o'clock to one, the long terraced parade in front
> of the handsome spa saloon is thronged with company, who promenade to the
> music of a good band disposed in an ornamental orchestra. Loiterers lounge
> upon the numerous seats which line the sides of the walk, and it is idleness—
> all. The afternoon is spent in drives into the country, or along the coast to
> Whitby and to Robin Hood's Bay, or is passed away in shopping, at Jancowski's
> drawing-room lounge and Parisian saloon, or perhaps at Theakston's library, or
> Alder's photographic studio. In the evening the promenade is again crowded by
> brilliant groups, who are in full dress; the ladies simply protecting themselves
> from cold by the addition of opera-cloaks. The musicians again perform, the
> gay ranks flit to and fro, the sea-lashes are more subdued, the vault of heaven is
> a deeper blue, and an indescribable charm is felt by all. Later in the evening the
> promenaders gradually disperse, some of them joining the conversazione and
> balls held at their hotels, or patronising the varied entertainments in the Spa
> Music Hall; others the drama in the Theatre Royal. This is how the pleasant days
> speed at Scarborough.[35]

8

Faith and Good Works

Religion and philanthropy are areas often neglected by historians of the seaside, yet they were part of the fabric of life. Rising numbers of respectable visitors to new or expanding resorts expected to be able to attend church services especially during a stay of what might amount to a month or more. Often, older places of worship could not accommodate the increase in visitors, while a growing fashionable suburb or a new resort might have no religious provision. Coatham, for example, had been raised to the status of a resort around 1770 by Charles Turner of Kirkleatham, but was left dependent on Kirkleatham for church services. Coatham's first church, Christ Church, was provided for under the terms of Teresa Vansittart's will, to be carried out by her daughter Teresa Newcomen, being consecrated in 1854. Both women were related to Turner. At other places, growth occasioned the expansion of religious provision. Thus, the multiplication of terraces and villas at Bridlington Quay led to the building of Christ Church (1841) to the north-west, and then Holy Trinity (1871) to the north-east. If all these were Anglican churches, Nonconformist faiths had, nevertheless, kept pace with the Church of England in building numbers of new churches. Nowhere is this more spectacularly illustrated than at Scarborough.

St Martin-on-the-Hill

The suburb at South Cliff, Scarborough, lacked a church, yet residences continued to spread along Ramsdale Road (Ramshill Road today). As a consequence, land was acquired in the 1850s towards the end of Albion Road near its junction with Ramsdale Road for the construction of a new Anglican church. The scheme looked like coming to little, however, since by 1859 a building committee had failed to raise sufficient funding. But this year was a significant one, since it brought to public prominence Mary Craven, the woman who was to fund the building of St Martin-on-the-Hill, the most extraordinary church of nineteenth-century Scarborough. Born in Hull in 1812, her father was Robert Martin Craven, a surgeon at Hull General Infirmary. He had also speculated in land, property and shipping. When he died in 1859 he was able to provide for his family with annuities and rents from property, dividing his personal fortune between his three surviving daughters Ann, Mary and Sarah.[36]

The Cravens' family home was at Albion Street, Hull, but they also possessed a home on the Esplanade, Scarborough. It was to this house that Anne and Mary came to reside together with their mother Jane after their father's death. Mary Craven, now in possession of an inheritance, supported the church-building scheme, but not by simply handing over money – her plans appear to have been more ambitious and more expensive than the building committee had anticipated. As she wrote to the local press concerning the scheme, 'If you decline the risk, and will give the affair into my hands, I will take the entire responsibility.'[37] It is also clear that substantial contributions were made by all sisters towards the building, furnishing and decoration of the church, although Mary Craven seems to have been in the driving seat. What Scarborough eventually got was a radical design of church worked on by cutting-edge artists of the day. The architect was G. F. Bodley, and Bodley's connection with William Morris and the Pre-Raphaelites brought a succession of artists up from London – Burne-Jones, Ford Maddox Brown, Dante Gabriel Rossetti, Philip Webb – to decorate and furnish the church. If the planning of the church had been rent with disagreements about cost and 'high church' decoration, it was completed relatively quickly, nevertheless. The foundation stone was laid in 1861 and the church consecrated in 1863. Its dedication was to St Martin of Tours, in memory of Robert Martin Craven.

St Martin-on-the-Hill, Scarborough. The tower terminates in a gable rather than a spire – typical of some early French churches in Normandy.

Burne-Jones's Daniel in
St Martin's Church.

 Bodley, Morris and the Pre-Raphaelites had created a radical design of church,
yet how did the middle-aged daughter of a provincial surgeon come to engage
such a notable artistic coterie? To begin with, Robert Martin Craven and William
Hulme Bodley – G.F. Bodley's father – doubtless knew each other, since not only
were they medical practitioners in the same city but also lived next door to each
other in Albion Street, Hull. The Bodleys were also related to the Etty family of
York and London, and Thomas Bodley Etty had married Sarah Craven, Mary's
sister. It is also worth pointing out that Bodley Etty's uncle was the painter
William Etty, and that the Bodleys had married into the family of the architect
George Gilbert Scott, in whose office G. F. Bodley began his training. In short,
given this family network, the choice of Bodley and his associates becomes less
surprising.

Ramsdale Congregational Church

South Cliff was not composed solely of Anglicans, for Nonconformity was also
strong. In 1863, the Congregationalists proposed building a church on a plot
of land opposite to the junction of Ramsdale Road and Albion Road and thus
close to St Martin's. Enter Titus Salt, Congregationalist, formidable West Riding
industrialist, and a frequent visitor to Scarborough. Salt paid for the site and,
as chairman of the building committee, brought in his own architectural team,
Lockwood and Mawson of Bradford, architects of Saltaire and Bradford Town
Hall. The foundation stone was laid in 1864 and the church opened in 1865. This
was a remarkably rapid feat of building on the parts of Lockwood and Mawson
and their contractor John Barry of Scarborough. It, too, was a Gothic design,

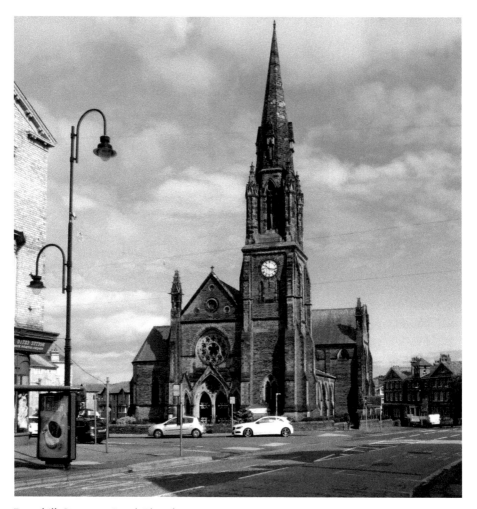

Ramshill Congregational Church.

externally elaborate but, in contrast to St Martin's, having an unpretentious interior.

Here was an issue: competition for God. As some Nonconformists saw matters, the Church of England had indulged in an aggressive campaign of church building from the 1830s and throughout the middle years of the nineteenth century. A way of counteracting this was by a similar programme of building. While Salt's and the Scarborough Congregationalists' motives lay primarily in providing a place of worship, it was, nevertheless, one that competed with St Martin's both in cost and scale, a rivalry noted by *The Architect* in March 1874 – the Congregational church was 'the very antithesis of Mr Bodley's church hard by'. Perhaps the most remarkable show of rivalry occurs in the handling of the steeples of each church. Bodley had designed a tower at St Martin's rising 100 feet – simple and finished with a gabled roof. Lockwood and Mawson

Its windows have an almost Cistercian austerity when compared with St Martin's.

designed an elaborately Gothic tower and spire 175 feet high. What is more, it stopped the view down Albion Road, drawing the eye past St Martin's to the new Congregational church. The effect is strikingly prominent in the townscape even today, especially in the view to the south-east, for while the eye lights on the unmistakeable outline of Bodley's St Martin's, the spire of Lockwood and Mawson's church soars above it.

The silhouettes of St Martin (left) and the Congregational church (right).

Good Works

Seaside resorts also provided opportunities for philanthropic acts, some uniquely connected with their locations by the sea. Financial support for lifeboats or mariners' orphans are examples. Others were concerned with health. If the seaside was considered beneficial to health, yet a prolonged stay could be enjoyed only by the wealthy few. To provide for the poor, numbers of convalescent homes were built, often by elite families. The convalescent home at Coatham was brought into being in this way in 1861 by Teresa Newcomen and her curate at Christ Church, Revd Postlethwaite. Newcomen provided land by the sea, while Postlethwaite seems to have supervised the scheme, whose patron was the Archbishop of York. Its purpose, according to a prospectus of 1862, was 'in providing suitable and inexpensive lodgings at the sea-side for the sick poor'. Other homes had arisen from similar principles. The Royal Northern Bathing Infirmary, Scarborough (1858–60), had as its patron Queen Victoria. Its subscription list reads like a directory of county families intermingled with women from eminent commercial and industrial families – Caroline Salt, for example, the wife of Titus Salt. At Saltburn, the Pease company erected a convalescent home in 1872, while perhaps the latest in the period under consideration was the children's convalescent home at Hornsea. Opened in 1908, it was a spin-off from the Victoria Hospital for Sick Children, Hull, funded in part by Thomas Ferens, a director of Reckitt and Sons.

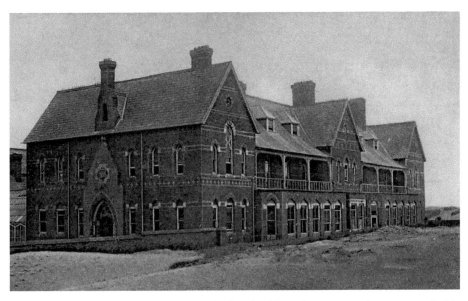

Coatham Convalescent Home (demolished), a building that attracted some remarkable architectural talent (new chapel, 1870, G. E. Street; enlargement, 1876–78, R. N. Shaw).

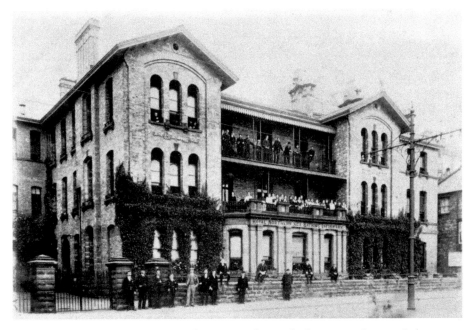

The Royal Northern Sea Bathing Infirmary, Scarborough, from an early twentieth-century postcard (W. B. Stewart, 1858–60).

And today. Solidly Italianate, it was the winning entry in a competition for the infirmary's design and probably among Stewart's first after he had returned from America. In the 1870s he returned to America where he died in Los Angeles in 1900.

Church building and good works were clearly of some significance at seaside towns, yet they might also serve functions other than the purely religious. They were a public expression in physical form of the philanthropy of wealthy individuals; fashionable visitors to a new church might also make it an occasion for promenading. As Jack Binns has commented in his history of Scarborough: 'leather-bound prayer books were conspicuous at the so-called church parade along the Esplanade.' What is more, all was framed by social class, and even philanthropy had its boundaries. Thus, when a request was made by the Saltburn Convalescent Home for its patients to have access to the Valley Gardens, the SIC was loath to grant it for fear of offending well-to-do visitors.[38]

In present-day accounts, none of this tends to be associated with resorts, nor do the bazaars and concerts to raise funds for good causes, nor the soirees and conversazioni for the same purpose, nor the celebrated preachers invited in the season. It all seems like a forgotten aspect of the seaside, hidden from history.

Saltburn
Convalescent
Home:
'domestic
Gothic freely
treated' – a
little too freely
nowadays,
having lost its
original gabled
windows and
roof to the
tower (Thomas
Oliver, 1872).

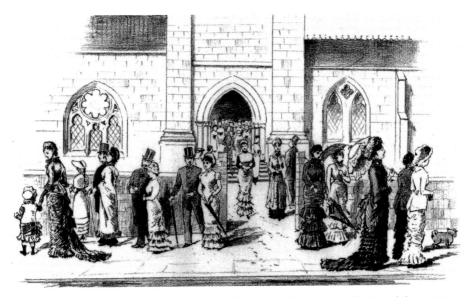

Fashionable churchgoers leave St Martin's. (*Sketches of Scarbro'*, John Dinsdale, 1881)

A Farewell

By 1900 the social tone of coastal resorts was changing. While elite families continued to visit Yorkshire's coast, and some chose to build houses, it could fairly be said its resorts were becoming less attractive. The reason usually given for such change – which was occurring across England – is the growth in mass holidays and the incursion into resorts of large numbers of day-trippers, or 'excursionists' as contemporary reports often termed them. It is not difficult to find evidence of this. On 11 August 1873, for example, 'A True Well-Wisher to Saltburn' wrote to the *Northern Echo* to express dismay at the invasion of Saltburn 'by a vast army of no less than five thousand excursionists'. He went on to say:

> I do most strenuously oppose these monster importations of persons into a comparatively small and quiet place to the utter discomfort of the visitors … Drunkenness, bad language, fighting, and I know not what else, have today characterised the crowds who have come down to refresh themselves at the expense of the residents.

What the complaint reveals is that space for leisure was becoming contested in an encounter that involved both class and culture.

Instances of similar complaints abound, and excursionists seem to have been viewed as a problem by middle-class and elite visitors. The terms used publicly to describe them reflect this repugnance – herds, hordes, the vulgar, the unwashed. Yet hostility towards trippers was probably bound up with a more complicated reason behind the eventual abandonment of coastal resorts by the well-heeled. Social scientists have written of the importance of leisure and culture as a means of maintaining social status. While greater access to the seaside by the working and lower middle classes may have offended some in terms of behaviour, but it also carried the implication that a sojourn by the sea was no longer the privileged experience it had once been. Social closure had to be achieved by other means, one of which lay in seeking holiday destinations farther afield or in more remote or neglected places. Travel abroad, however, had begun well before the later nineteenth century, and the practice was embedded perhaps in

the European tours undertaken by aristocratic families of the eighteenth century. The development of railway systems on the Continent from the 1840s further facilitated Continental travel, so that It began to become usual for some elite families to tour the Continent or to make holiday excursions farther afield, while others bought villas abroad. Accounts of such journeys can be found in letters or journals, or even in obituaries. Sir William Lowthrop, for instance, of Alga House, Scarborough, died in 1853 while at Nice; Edward Henry Woodall, from a prominent Scarborough banking family, possessed a villa in Nice by the 1890s. Others went farther or attempted grander itineraries. John Bell of Rushpool Hall, Saltburn, had a villa at Algiers where he died in 1888; the Holden family, wool combers of international repute, had homes at Keighley in West Yorkshire, a chateau at Croix (much of their business was in northern France) and a villa in Algiers; Sir George Sitwell of Renishaw Hall, Derbyshire, and Woodend, Scarborough, bought the Castello di Montegufone near Florence and from 1909 began to restore it.

Travel in Europe, a villa there or on the Mediterranean coast, became a mark of distinction for some. Yet one might argue that there was still the danger of social dilution even here, for the 'package holiday' industry was already afoot – Thomas Cook's first European tours began in the 1850s. These were, nevertheless, of a different order to the activities of the elite who, on the one hand, visited the great European and Mediterranean cities to absorb their culture, and on the other might spend time and money enjoying pleasures and activities unavailable in England – casinos, for example, or climbing in the Swiss Alps.

But these were the preserve of the very rich and beyond the means of those lower down the economic scale. Yet even in the foothills of wealth there were those who shared similar predilections when it came to travel and leisure. Towards the end of the nineteenth century social differentiation for them might take the form of holidays to places not developed as resorts, out of the way of tourists, and often the destinations of those in search of the 'authentic' character of the coast. In this latter respect it might involve interaction with local populations such as farm labourers, fishermen or fisherwomen – the true people of the coast with a strong sense of identity. Robin Hood's Bay, Runswick Bay, Sands End or Staithes were typical locations in Yorkshire. Staithes in particular became a favourite of artists, and a small colony had established itself there by 1900. If numbers of these sojourners were not elite visitors as defined at the beginning of this book, a fair proportion had originated from such backgrounds. Art and place became their medium of differentiation, and rugged coastal villages provided artistically sound subjects. Dame Laura Knight might well have been describing the feelings of numbers of people who holidayed at such locations in the late nineteenth and early twentieth centuries when she wrote in her autobiography of what Staithes had meant to her. She enjoyed its uncorrupted nature, 'a real fishing-village,

unspoilt by summer visitors', and she loved 'the strange race of people who lived there, whose stern almost forbidding exterior formed such contrast to the warmth and richness of their natures'.[39]

The changing nature of holidays and travel did not take place overnight, but seems to have been a long-run trend throughout the nineteenth century. Furthermore, many elite families continued to enjoy the county's coastal resorts until the end of the century. Given this circumstance, one is tempted to argue that the continuing attractiveness of coastal resorts to the wealthy and their enjoyment of foreign travel were parallel developments, rather than a gradual drift away from the English coast. To some extent this is true. The select character of Scarborough, for example, was probably at its height in the mid- to late nineteenth century, yet this was also a time when travel to Europe was increasing.

Whatever interpretation one might place on this, the fact is that by 1900 the social tone of some of Yorkshire's resorts had changed. Certainly, Redcar and Withernsea had become associated with bank holiday excursions and short working- or lower-middle-class holidays. Bridlington Quay, Hornsea and Saltburn were not far behind. Filey, Scarborough and Whitby survived longest as retreats for the well-to-do, but even here some of the old and exclusive glamour had worn off. Osbert Sitwell in *Before the Bombardment* provides a perceptive view of 'Newborough' (Scarborough), its elderly inhabitants and their social life around 1914. They represented the passing of an era, like the houses and rooms they occupied, 'facing south in square, crescent and terrace … unaltered and apparently unalterable, ever bathed in the sunset glow of Victorianism'.

The writing was on the wall. By the 1930s, Billy Butlin was already assessing a site to the south of Filey for a holiday camp, the plans for which Filey Urban District Council initially rejected on the grounds that it was 'not in keeping with the select nature of Filey' – even though it was 2 miles from the centre of the town.[40] The UDC, however, could not turn back the tide, and was eventually to relent in 1939. After 1945, land to the south of Filey became the location of holiday camps, chalets and caravans, and Butlin's Ltd continued to buy land in the area for further expansion. There is no more fitting symbol of such change than the White House, a modernist villa built in the vicinity of the holiday camp in the interwar years. After the war it was to become one of the residences of Butlin himself, and perhaps the last such elite villa to be built at a Yorkshire resort.

Sir Billy Butlin's house at Filey.

Notes

1. Young, Arthur, *A Six Months Tour through the North of England* (London, 1770), p. 112.
2. Referred to in Neave, David & Susan, *Bridlington: An Introduction to its History and Buildings* (Otley: Smith Settle, 2000), p. 127.
3. White, William, *History, Gazetteer, and Directory of the East and North Ridings of Yorkshire* (Sheffield, 1840); Meadley, C., *Memorials of Scarborough* (London, 1890), p. 166.
4. *Hull Packet*, 11 December 1840.
5. Ibidem, 30 April 1841.
6. East Riding of Yorkshire Archives and Local Studies, deposited building plans, BOBR/6/2/1, No. 187.
7. Illustrated in *The Building News*, 28 February 1896, pp. 310–11.
8. North Yorkshire County Record Office, Scarborough Council Building Control Plans DC/SBC, No. 464, 17 March 1864.
9. North Yorkshire County Record Office, Scarborough Council Building Control Plans DC/SCB No. 176.
10. Although Sharp seems to have been connected with the scheme from its inception, he probably did not design the villas associated with it.
11. These houses are shown on Thomas Jefferys' plan of Scarborough, surveyed between 1767 and 1770, and also on a print by W. Tindall of *c.* 1830. They were remodelled probably between 1850 and 1880, but the earlier detailing of one or two remains.
12. These events can be followed in the *Bridlington Free Press,* see 10 October and 5 December 1868, and 16 January 1869.
13. Hutton, William, *A Trip to Coatham: A Watering Place in the North Extremity of Yorkshire* (London, 1810), pp. 128–30.
14. *The Hull Advertiser and Exchange Gazette,* 2 June 1837.
15. *London Evening Standard,* 12 May 1848.
16. Baker, Edward, *Sojourn in Scarborough, 1850* (Leeds: Old Hall Press, 1984), pp. 8–9.
17. See account in the *Illustrated London News,* 20 September 1856.
18. *Building News,* 17 May 1867; *The Architect,* 28 February 1874.
19. *Scarborough Gazette,* 25 July 1867.

20. *London Evening Standard,* 25 June 1862.

21. Cowley, Percy Tunnicliff, *In the Western Highlands of Scotland, and Holiday Notes on Scarborough* (London: E. W. Allen, 1890), pp. 51–52.

22. *Leeds Mercury,* 4 July 1896; 8 July 1896; *York Herald* 2 September 1896; *Leeds Mercury* 31 December 1896.

23. *Whitby Gazette,* 12 August 1898.

24. *Yorkshire Post and Intelligencer,* 31 July 1900.

25. Gray, Fred, *Designing the Seaside: Architecture, Society and Nature* (London: Reaction Books, 2006), p. 177.

26. Theakston, S. W., *Guide to Scarborough* (Scarborough, 1854), p. 91.

27. Pennant, Thomas, *A Tour in Scotland 1769* (London, 1776), p. 24.

28. *Yorkshire Gazette,* 8 June 1861.

29. *Newcastle Courant,* 24 December 1773; Robinson, Francis Kildale, *Whitby: Its Abbey and the Principal Parts of the Neighbourhood* (Whitby, 1860), p. 193.

30. Greenwood, Thomas, *Museums and Art Galleries* (London, 1888), p. 4; Anon., *Life Beneath the Waves and a Description of the Brighton Aquarium* (London, 1871), pp. 9–10; *Scarborough Gazette,* 24 April 1873.

31. Estimates of contemporaries give figures ranging from 2.5 to 3 acres. It would seem that the aquarium itself covered around 2.5 acres, while the site was of around 3 acres.

32. Cross, Wilbur L., *The Letters of Laurence Sterne To His Most Intimate Friends* (New York, 1904), Vol. 2, p. 60, letter XCIX.

33. University of Manchester, Rylands Library, Special Collections, English Manuscripts 1126, fo 167–68.

34. Sitwell, Osbert, *Before the Bombardment* (London: Gerald Duckworth & Co. Ltd, 1926), Chapter XX 'St Martin's Summer' – fiction, but a satire on Scarborough and its society, nevertheless.

35. *The Builder,* Vol. XIX, 9 November 1861, p. 765.

36. Will of Robert Martin Craven, Probate Service, 22 February 1859.

37. *Scarborough Gazette,* 18 June 1861.

38. Cited by Louise Flanagan, *Saltburn-by-the-Sea 1860–1890: A Vision Realised?,* dissertation for The Open University module A826 MA History part 2 (2019), p. 37.

39. Knight, Laura, *Oil Paint and Grease Paint* (New York: Macmillan, 1936), pp. 73, 75.

40. *Boston Guardian,* 31 May 1939. For a useful summary of events see Fearon, Michael, *Filey, from Fishing Village to Edwardian Resort* (Pickering: Hutton Press, 1990), pp. 112–18.

Bibliography

Individual Resorts

Binns, Jack, *History of Scarborough: From Earliest Times to the Year 2000* (Pickering: Blackthorn Press, 2001)

Fearon, Michael, *The History of Filey: From Earliest Times to the Present Day,* (Pickering: Blackthorn Press, 2008)

Pearson, Trevor, *Scarborough: A History,* (Chichester: Phillimore, 2009)

Neave, David and Susan, *Bridlington: An Introduction to Its History and Buildings,* (Otley: Smith Settle, 2000)

White, Andrew, *A History of Whitby* (Chichester: Phillimore, 1993)

Britain Generally

Pimlott, J. A. R., *The Englishman's Holiday: A Social History* (Hemel Hempsted: Harvester Press, 1976)

Walton, John K., *The English Seaside Resort: A Social History 1750–1914* (Leicester: Leicester University Press, 1983)

Websites

Saltburn: www.saltburnbysea.com

Hornsea: www.british-history.ac.uk/vch/yorks/east/vol7/pp273-29

Index

About the Author

Dr George Sheeran is Honorary Post-Doctoral Fellow at the University of Bradford where he has taught architectural history and urban development. His books include *Brass Castles: The West Yorkshire New Rich and Their Houses 1800–1914* (2006) and *The Mosque in the City: Bradford and Its Islamic Architecture* (2015). With Amberley he has published *Bradford in 50 Buildings* (2017).